IMAGES of America
WASHINGTON CROSSING

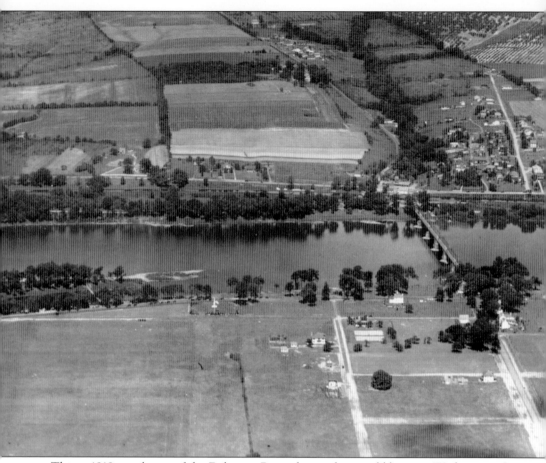

This c. 1918 aerial view of the Delaware River shows what would become Washington Crossing Historic Park, Pennsylvania (foreground), and Washington Crossing State Park, New Jersey. At the time of the crossing, two hamlets were located here named for the ferry operators that crossed the river. The McConkey ferry on the Pennsylvania side was operated by Samuel McConkey, and the Johnson ferry, located on the New Jersey side, was operated by James Slack. In the years that followed the 1776 crossing, both ferry communities became known by different names. McConkey's Ferry became known as Taylorsville, after Mahlon K. Taylor, and Johnson's Ferry became known as Bernardsville, after Bernard Taylor. Today, both communities are known as Washington Crossing. In the early 1900s, Dr. Isidor P. Strittmatter, a Philadelphia physician, began purchasing properties along both shorelines adjacent to the crossing. For the next 15 years, Dr. Strittmatter acquired more than 300 acres of ground that was connected to the historic crossing. Strittmatter was passionate about the American Revolution and held a great interest in saving significant historical properties. His work played a major role in the subsequent planning and development of the two parks. (Trenton Free Public Library.)

ON THE COVER: On January 23, 1947, some 40 pledges of Phi Sigma Nu fraternity from Rider College (now Rider University) staged a re-enactment of Washington's crossing of the Delaware. The nonhazing event was the idea of two Rider students, Frank Ewart and Donald Reynolds, as an entertaining way to draw attention to the fraternity. George Chafey (standing) portrayed Gen. George Washington, Joseph Brelsford was Gen. John Sullivan, William Clark was Gen. Nathanael Greene, and Theodore Genola is dressed in a buckskin uniform. (Rider University Archives.)

IMAGES of America
WASHINGTON CROSSING

Robert W. Sands Jr. and Patricia E. Millen

ARCADIA
PUBLISHING

Copyright © 2022 by Robert W. Sands Jr. and Patricia E. Millen
ISBN 978-1-4671-0800-3

Published by Arcadia Publishing
Charleston, South Carolina

Printed in the United States of America

Library of Congress Control Number: 2021952352

For all general information, please contact Arcadia Publishing:
Telephone 843-853-2070
Fax 843-853-0044
E-mail sales@arcadiapublishing.com
For customer service and orders:
Toll-Free 1-888-313-2665

Visit us on the Internet at www.arcadiapublishing.com

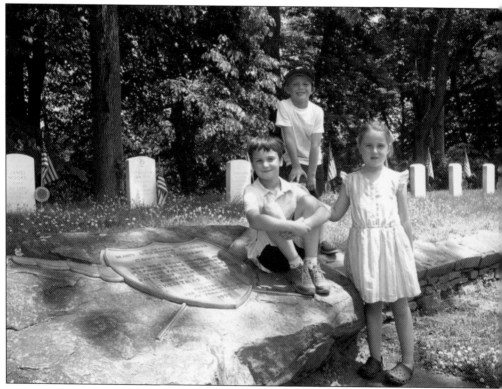

This book is dedicated to the memory and honor of all the soldiers, known and unknown, who fought during the American Revolution and to Henry Millen (age seven), James Baldino (age six), and Abigail Millen (age five)—so you always remember your history. Love, Gee Gee.

CONTENTS

Acknowledgments		6
Introduction		7
1.	The Crossing, "The Turning Point of the Revolution"	9
2.	Washington Crossing Historic Park, Pennsylvania	23
3.	Washington Crossing State Park, New Jersey	45
4.	The Painting, Emanuel Leutze's Masterpiece in Art and History	69
5.	The Many Facets of the Delaware River	83
6.	"Let History Huzzah for You"	103

Acknowledgments

This book was written to honor the 1776 crossing of the Delaware by Gen. George Washington and his army and the parks that mark its place in history. The images enclosed, however, preserve more than the events of the American Revolution. For generations of people, the parks have been an extension of their own backyards and hold fond memories of hiking through wooded trails—or along the canals—family picnics and outdoor play watching or witnessing history relived on Christmas day. We have attempted to capture these timeless moments that make up the story of both parks.

We gratefully acknowledge the people who have made this collective work possible: Peter Osborne, whose monumental history of both parks guided this project; Annette Earling and Michael Mitrano of the Washington Crossing Park Association for sharing their digital archive; Emma Falcon, Alexandra DeAngelis, and Rayna Polsky of the Bucks County Historical Society; Jennifer Martin and Kimberly McCarty of the Washington Crossing Historic Park; Laura M. Poll and Mimi McBride of the Trenton Free Public Library; Robert Congleton of the Rider University Archives; Donald Cornelius of the New Jersey State Archives; John Church of the Princeton Amateur Astronomers Association; Kellee Blake of the Washington Crossing United Methodist Church; Bonita Craft Grant of the Hopewell Valley Historical Society; and Corey Bogel, a meteorologist at the National Oceanic and Atmospheric Administration. We are especially thankful to Robert G. Meszaros, Ronald Rinaldi II, and Ross Seiber for openly sharing their private collections. We also extend a note of special appreciation to Charles and Katherine Hutton Tweedy of the Washington Crossing Foundation for their time and generosity and Lynn Snodgrass-Pilla for her valuable assistance. Lastly, we would like to express our gratitude to our spouses, Alexander B. Bartlet and Brian W. Millen, for their love and support. Thank you all!

We would like to acknowledge the following institutions and individuals by whom images were provided: authors' collection (AC); Bucks County Historical Society (BCHS); Dave Deifer (DD); New Jersey Department of Environmental Protection Green Acres Program (DEP); New Jersey Division of Parks and Forestry (NJDPF); Barbara Cooper Felver (BCF); Georgetown University (GU); Hopewell Valley Historical Society (HVHS); Library of Congress (LOC); Robert G. Meszaros (RGM); Metropolitan Museum of Art (MET); New Jersey State Archives (NJSA); Noden family (NF); Peter Osborne Collection (POC); Pennsylvania Historical and Museum Commission, Pennsylvania State Archives (PHMC); Princeton Amateur Astronomers Association (PAAA); Rider University Archives (RUA); Ronald Rinaldi II (RR); Ross Seiber (RS); Richard A. Speranza (RAS); James E. Wiles III (JW); Washington Crossing Foundation (WCF); Washington Crossing Park Association Archives (WCPAA); Washington Crossing United Methodist Church (WCUMC); the Museum of Fine Arts in Boston (MFA); and Trenton Free Public Library (TFPL).

INTRODUCTION

By the time the American colonists declared their independence in July 1776, they had already been fighting the British for over a year. In the fall of 1776, after a series of defeats, the newly formed Continental Army under the command of Gen. George Washington had been driven out of New York, across New Jersey, and into Pennsylvania. The ragtag army of Continentals encamped on the western shore of the Delaware River. The Revolution was not going well.

With few provisions, desertion rampant, and the enlistments of most his soldiers coming to an end, Washington, in consult with his generals, devised a bold plan. They would sneak across the Delaware on Christmas night to attack the British-Hessian garrison in Trenton, New Jersey. Washington ordered boats along the Delaware to be commandeered to move 2,400 men, horses, and artillery.

On the stormy night of December 25, 1776, the Delaware River was chocked with ice as a nor'easter pelted the soldiers with sleet and snow. It took 10 hours to move Washington's army across the river to congregate by the Johnson Ferry House on the Jersey side. The nine-mile march to Trenton did not begin until 4:00 a.m. on December 26—the army losing all chance to enter the city under the cloak of darkness. But with the watchword of "Victory or Death," Washington, determined, moved on, and the plan worked! The Hessians were taken off-guard and the Continentals won, capturing nearly a thousand men and a large cache of supplies. This decisive victory was followed by two more, the Second Battle of Trenton on January 2, 1777, and the Battle of Princeton on January 3, 1777. The American cause no longer seemed lost.

Following four more years of brutal warfare, the British Army finally surrendered at Yorktown, Virginia, in 1781. At a dinner marking the end of the hostilities, British commander Lord Cornwallis toasted Washington: "And when the illustrious part that your excellency, General Washington has borne in this long and arduous contest becomes a matter of history, fame will gather your brightest laurels rather from the banks of the Delaware than from those of the Chesapeake." For generations after the Revolution, only two granite monuments, erected in 1895, marked the crossing sites on both sides of the Delaware. As the 150th anniversary of the United States approached, however, concerned citizens, patriotic orders, and state officials began major movements to fully commemorate the crossing in both Pennsylvania and New Jersey. Washington Crossing State Park, encompassing areas in Mercer and Hunterdon Counties in New Jersey, was created in 1912. The Washington Crossing Historic Park in Bucks County, Pennsylvania, was created shortly afterward in 1917. Both parks have undergone many changes throughout the years, but the crossing site of 1776 is still recognizable.

The dramatic scene of Washington standing in a Durham boat in 1776 in the icy river with the flag furling in the wind has been ingrained into the American consciousness. It is recognized the world over. This imagery has been immortalized in paintings, sculptures, propaganda, and even in modern-day advertising. Hundreds of re-enactors continue to relive the event every year on Christmas day. This illustrated book was created to preserve the pictorial history of the crossing and the parks that flank the river—for all the thousands of visitors who come each year to stand on its banks to marvel at the site where Washington crossed the Delaware.

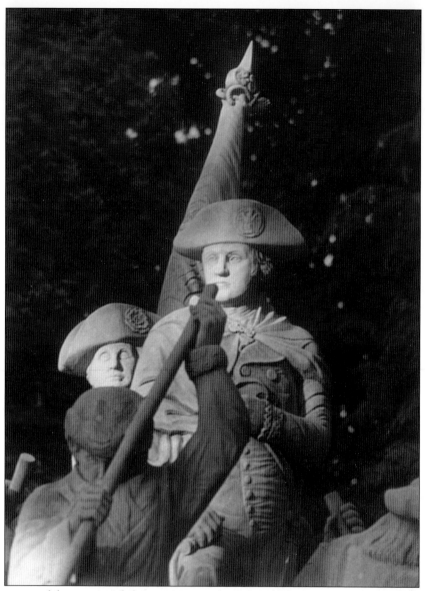

After a series of devastating defeats in New York, General Washington retreated across New Jersey in November 1776 with what was left of the Continental Army. The Jersey people offered little in support for the exhausted and hungry soldiers. On December 18, Washington wrote to his brother Samuel about the conduct of the colonists, "Instead of turning out to defend their country . . . they are making their submissions as fast as they can. . . . I think the game is pretty near up." Encamped along the Pennsylvania shores of the Delaware River, Washington knew he had to strike. The surprise attack on the British-Hessian garrison in Trenton was conceived. But a powerful storm on December 25 put the river crossing and assault hours behind schedule. The army would enter the city in daylight. Washington contemplated suspending operations. He wrote afterward to John Hancock, "I was certain there was no making a Retreat without being discovered." So the army advanced, and the ultimate victory turned the scales—the Americans becoming "liberty-mad again." Washington's face on the limestone statuary near the Washington Crossing Inn located in Pennsylvania reveals his determination against all odds. (WCF.)

One
THE CROSSING, "THE TURNING POINT OF THE REVOLUTION"

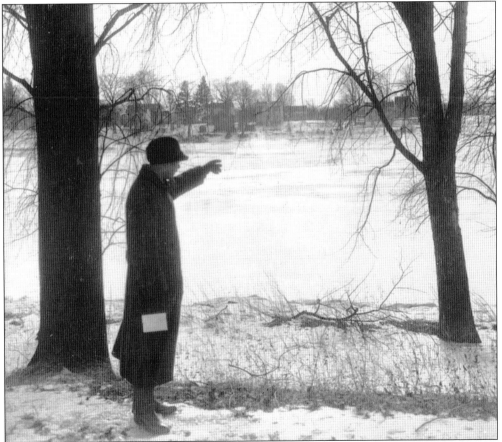

The historic Delaware River flows 419 miles from New York State to the Delaware Bay. The Lenni Lenape people called the river through their homeland Lenapewihittuk. It was explored by Henry Hudson in 1609 but was given its English name, Delaware, after Sir Thomas West, Third Baron De La Warr. In this c. 1915 image, a tour guide points toward Pennsylvania along the banks of the river recounting Washington's historic crossing. (AC.)

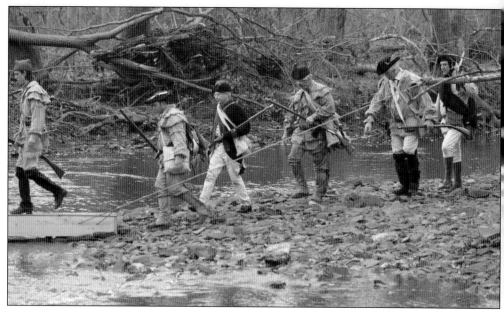

In November 1776, Washington's army faced defeating blows by the British on Long Island and at both Forts Washington and Lee along the Hudson River. Retreating across New Jersey, Washington crossed his men over the Delaware River into Pennsylvania on December 8. Washington positioned 6,000 men along the river above and below Trenton. These men were cold and hungry. They slept on the ground and ate what they could find. (RS.)

Needing a victory, Washington began planning a bold surprise attack against British and Hessian forces positioned in Trenton, New Jersey. He encamped his army along the banks of the Delaware near McConkey's Ferry. When Washington's army first arrived there, he had 4,000–6,000 men, including 1,700 soldiers who were unfit for duty and needed hospital care. In the retreat across New Jersey, Washington had lost precious supplies as well as contact with two important divisions of his army. (RS.)

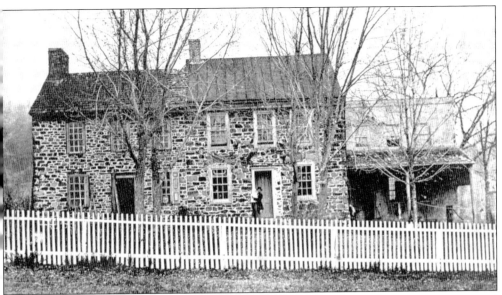

The William Keith House, located in Upper Makefield Township, Pennsylvania, was constructed in about 1742. Pictured here in December 1879, it became General Washington's headquarters from December 14 to 24, 1776, after he moved from the Thomas Barclay House in Morrisville. It is believed that Washington relocated here to be near a supply depot located in Newtown. Washington feared that the enemy would cross the Delaware in an attempt to capture the much-needed ammunition for his army. (BCHS.)

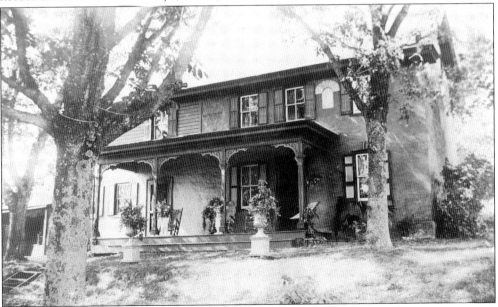

The Samuel Merrick House, located in Upper Makefield Township, is seen here as it appeared in about 1900. Suspecting that he was being spied upon, Washington met with his council of war late on Christmas Eve at the Merrick House, located across the road from the Keith House. Attending were Major Generals Nathanael Greene and John Sullivan; Brigadier Generals Lord Stirling, Matthias Fermoy, Hugh Mercer, Adam Stephen, and Arthur St. Clair; and Colonels Paul D. Sargent, John Stark, John Glover, and Henry Knox. (BCHS.)

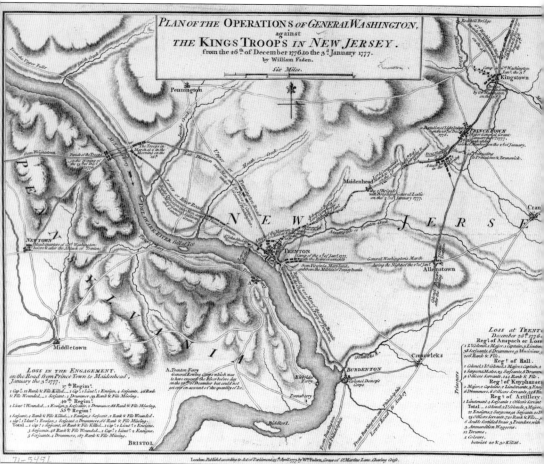

This map illustrates Washington's New Jersey campaign, from December 26, 1776, to January 3, 1777, and details the number of British and Hessian losses, along with the routes taken by the American troops to Trenton. Washington's army's morale was at a low ebb, and for many, their enlistments were to expire at the end of the month. Washington's goal was to attack the roughly 1,400 German soldiers, known as Hessians, who had taken up winter quarters in Trenton. He engaged Col. John Cadwalader to lead his force of 1,200 Philadelphia militia and 600 Continentals to cross the river from Bristol into Burlington to prevent the British and the Hessian units there from racing north to support the Hessians at Trenton. Gen. James Ewing's forces of 800 Pennsylvania militia were to cross at Trenton Ferry and take up defenses on the bridge over the Assunpink Creek to prevent the enemy from retreating from Trenton, while Washington's 2,400 soldiers would cross at the McConkey and Johnson ferries, located 10 miles north of Trenton. As weather conditions worsened, both Cadwalader and Ewing's forces were unable to cross the ice-choked Delaware. Washington and his main forces were able to cross, although they were delayed by more than three hours. (LOC.)

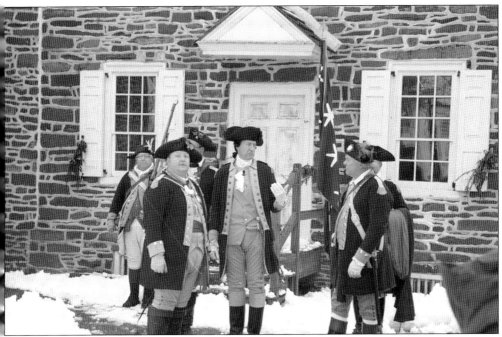

On Christmas morning, Washington met with his commanding officers. New intelligence intercepted warned the British had intentions "to cross the Delaware as soon as the Ice is sufficiently strong" and take Philadelphia, hang the signers of the Declaration of Independence, and bring the colonies back to the crown. Washington sent word to his friend Robert Morris in Philadelphia to "take the necessary Steps for the Security of such public and private property." Washington's army now positioned along the western banks of the Delaware gave him an advantage to defend the city. (RS.)

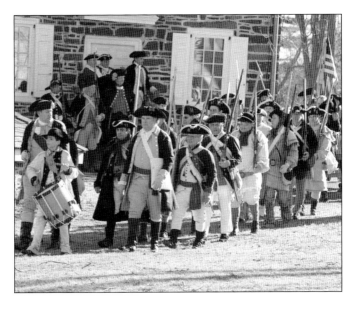

About 4:00 in the afternoon on Christmas day, the sounds of American drums began to beat calling troops for the evening parade, but this time, the call appeared different. During this muster, instructions went out that every man was to carry a musket, even officers and musicians. John Greenwood, a fifer in his regiment, recalled, "Every man had 60 rounds of cartridges served out to him. None but the first officers knew where we were going or what we were going about, for it was a secret expedition." (RS.)

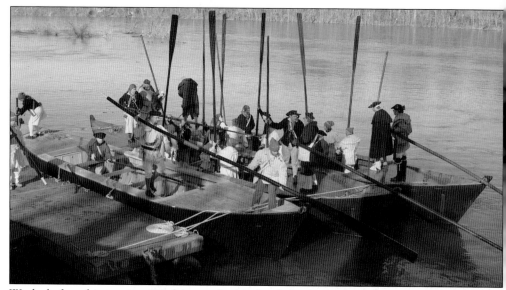

Weeks before the crossing, Washington had ordered that every boat along the Delaware River from Trenton north be commandeered and secured, making the boats unattainable to the British. Washington particularly requested Durham and ferry boats due to their flat bottoms and deep sides, allowing them the capability to carry many men and supplies across the river quickly. The boats were hidden on the Pennsylvania side of the river behind islands so they were not visible from New Jersey. (RS.)

These re-enactors portray Col. John Glover's 14th Continental Regiment, also known as the Marblehead Regiment, during the Christmas day Crossing Re-enactment at the Washington Crossing Historic Park (WCHP) in 2007. Glover's regiment was given the duty to ferry Washington's troops across the Delaware. This New England regiment, comprised of seafaring men from the area around Marblehead, Massachusetts, included Black and Native people who were skilled in the ways of maneuvering a vessel in any type of weather. The original regiment, enlisted for a year and a half, disbanded after the Battle of Trenton. (RS.)

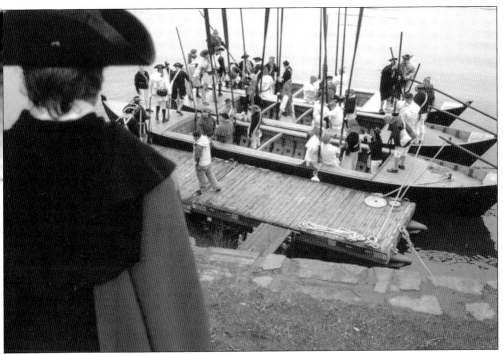

The crossing began at 5:00 p.m. with temperatures in the upper 20s. Floating cakes of ice began to appear on the river. Washington patiently watched as 2,400 soldiers, 18 cannons, and 75–100 horses crossed the Delaware. By 11:00 p.m., the weather had turned for the worst. One of his officers wrote, "He [Washington] stands on the bank of the stream, wrapped in his cloak, superintending the landing of his troops. He is calm and collected, but very determined. The storm is changing to sleet and cuts like a knife." (RR.)

Gen. Adam Stephen's brigade was the first to disembark on the New Jersey shore. Once across, he was ordered to "appoint a guard to form a chain of sentries round the landing place at a sufficient distance from the river to permit the troops to form, this guard not to suffer any person to go in or come out, but to detain all persons who attempt either." Washington would cross over soon after. Many began to pull down nearby fences for firewood, as the storm was increasing rapidly. (RR.)

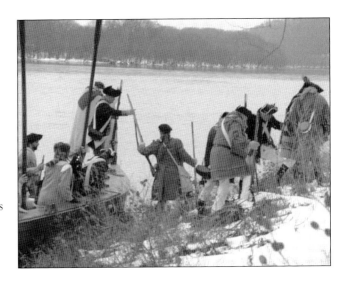

The Johnson Ferry House, located in the Washington Crossing State Park (WCSP) and built around 1740, was owned by Garret Johnson, who operated a plantation and a ferry service across the Delaware. The structure was most likely used by Washington and his officers during the crossing campaign. A Washington staffer's diary entry notes, "Dec 26, 3 a.m.—I am writing in the ferry house and the troops are all over, and the boats have gone back for the artillery. . . . I have never seen Washington so determined." (WCPAA.)

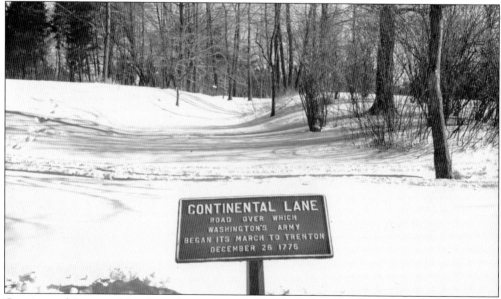

Continental Lane, a 1.4-mile pathway through the WCSP, is traditionally believed to be the route that Washington's army traveled shortly after crossing the Delaware. The path, covered in deep snow and ice as seen in this c. 1960s image, was rough and ascended upward for about 200 feet from the river, and the soldiers found it difficult to maneuver artillery in the dark. Many of the soldiers were barefoot or wore rags wrapped around their feet, leaving bloody footprints in the snow. (WCPAA.)

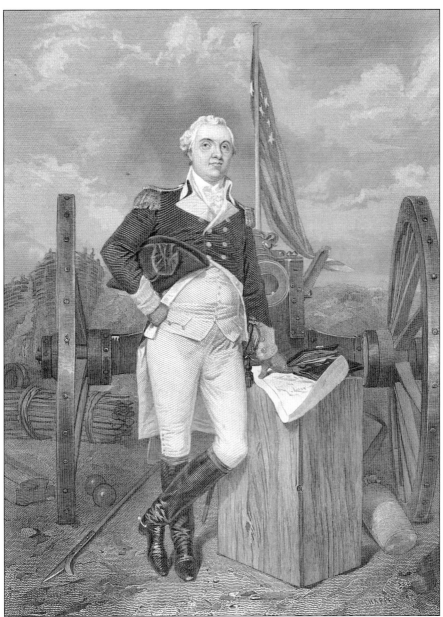

Col. Henry Knox was a self-taught student of military history whom Washington entrusted with some of the most critical operations of the Revolutionary War, including the 1776 Christmas crossing. Knox persuaded Washington not to give up as the storm worsened and maneuvers progressed into the early morning hours. Soldiers could hear Knox's booming voice as he directed the horses, 18 field pieces, and 350 tons of ammunition loaded onto the ferries. "Floating ice in the river made the labor almost incredible," Knox would later write to his wife, but "perseverance accomplished what first seemed impossible." Knox had completed the grueling mission of stealing the artillery from Fort Ticonderoga in 1775, securing the arsenal for use by the Continental Army. The mobile field guns under Knox's command would prove crucial to the victory at Trenton. "With respect to General Knox," Washington once wrote, "there is no man in the United States . . . whom I have loved more sincerely, nor any for whom I have had a greater friendship." (AC.)

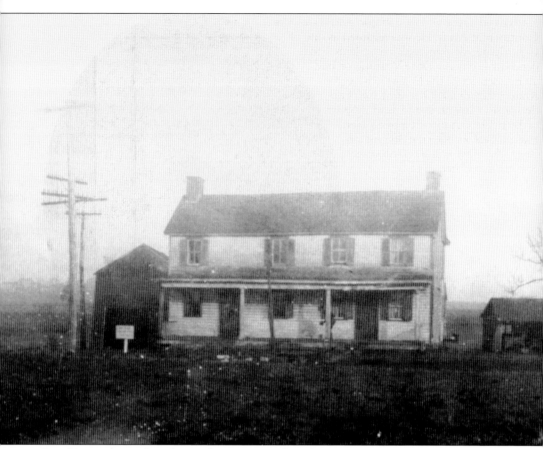

Bear Tavern, located on the northeast corner of Washington Crossing–Pennington and Trenton-Harbourton Roads, is pictured here in about 1930. It was here that Washington's army would turn southeast onto Bear Tavern Road, cross the deep ravines of Jacob's Creek, and march together until they reached the small hamlet of Birmingham (now West Trenton). In a letter to Congress, dated December 27, 1776, Washington writes in part, "I form'd my detachments into two divisions one to March by the lower or River Road, the other by the upper or Pennington Road. As the Divisions had nearly the same distance to March, I ordered each of them, immediately upon forcing the out Guards, to push directly into the Town," Maj. Gen. Nathanael Greene's division headed east to approach Trenton by the Scotch and Pennington Roads; the other, led by Maj. Gen. John Sullivan, had orders to continue on the River Road and "enter the town by Water Street." The old tavern, which was a private residence and farmhouse, became part of the Washington Crossing State Park in 1926. The building serves currently as the park's headquarters and office for the superintendent and park police. (RGM.)

Nathanael Greene was a major general of the Continental Army. He was regarded as one of Gen. George Washington's most talented and dependable officers. Once Washington had all his men across the Delaware River, he strategically divided his army into two divisions. Greene would lead 2,690 of Brig. Gen. Adam Stephen's men toward Trenton along the Pennington Road. Washington and his entourage accompanied Greene. (AC.)

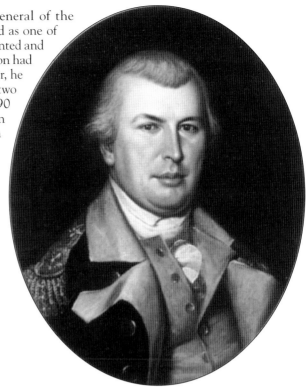

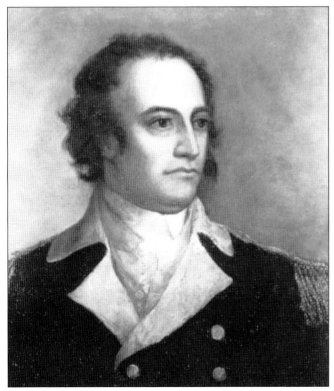

Maj. Gen. John Sullivan, a native of New Hampshire, rose to become one of the Continental Army's most dedicated fighters during the American Revolution. In September 1776, Sullivan was released in a prisoner exchange and returned to the army in time to join Washington and cross the Delaware into New Jersey. He was given the charge to lead his division along the river road into Trenton. Today, this route is known as Sullivan Way. (AC.)

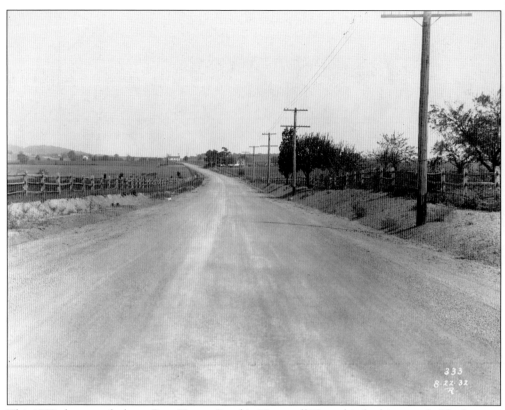

This 1932 photograph shows Bear Tavern Road in Hopewell Township looking north. The historic Bear Tavern is visible in the distance, and if this picture were taken today, the Bear Tavern Elementary School would appear to the right. As Washington's army marched southward through hardwood forests toward Trenton, Colonel Knox recalled that upon reaching the crest of Bear Tavern Road, the soldiers were thankful to be finally walking on flat ground and that the wind and relentless snow were no longer blowing in their faces. (RGM.)

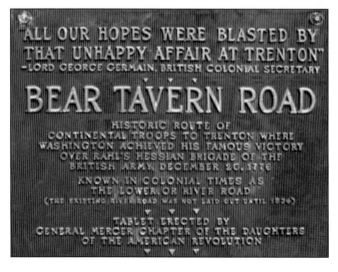

Along a stretch of Bear Tavern Road in Ewing Township, four memorial markers were placed between 1929 and 1930 to commemorate the route Washington's army traveled to Trenton in December 1776. This marker, dedicated in 1930, is set into a large boulder on the east side of Bear Tavern Road just north of Windybush Way. The second is near the intersection of Bear Tavern and Upper Ferry Roads, a third is in front of the Mountain View Golf Club, and a fourth is near Jacob's Creek. (Revolutionarywarnewjersey.com.)

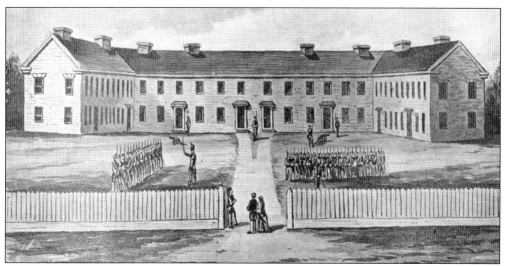

On December 14, 1776, nearly 1,400 Hessians arrived in Trenton under the command of Johann Gottlieb Rall to establish winter quarters. The term "Hessians" refers to German mercenaries hired by the British to help fight during the American Revolution. Many came from the German states of Hesse-Kassel and Hesse-Hanau. Although Rall had received warnings of colonial movements, his men were exhausted and unprepared for Washington's attack. A Hessian soldier wrote in his diary, "We have not slept one night in peace since we came to this place." (TFPL.)

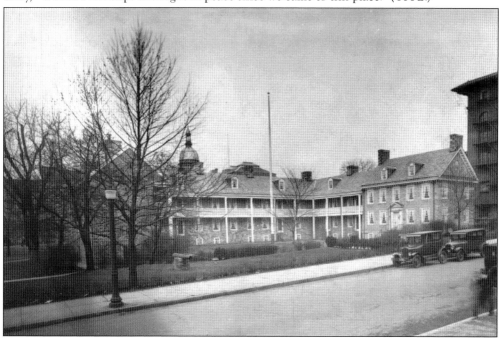

The Old Barracks, located on Barracks Street in Trenton, was built in 1758 to house British soldiers during the French and Indian War. Seen here in 1921, it is the only remaining colonial barracks in New Jersey and one of the only physical surviving structures from the Battle of Trenton. The Officers' House, seen to the right, was used to house British prisoners of war. After the Battles of Trenton and Princeton, the barracks became an army hospital under Dr. Bodo Otto, who oversaw smallpox inoculations for the Continental Army. (TFPL.)

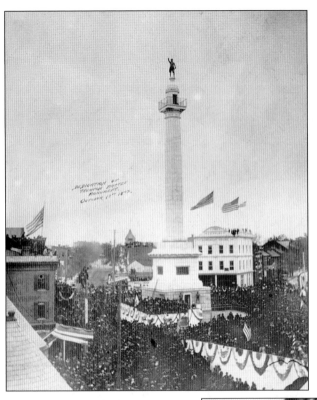

A rare image shows the dedication of the Trenton Battle Monument on October 19, 1893. The monument was designed by John J. Duncan, the architect of Grant's tomb. Eight governors from the original 13 states attended the elaborate ceremony. The date commemorated the surrender of Gen. Lord Cornwallis at Yorktown in Virginia. The monument, located within the Five Points neighborhood of Trenton, marks where the Continental troops placed their artillery during the First Battle of Trenton on December 26, 1776. It was at this location that Washington's army prevented the Hessian troops from organizing an effective counterattack. (TFPL.)

The Trenton Battle Monument stands 148 feet above street level. A 13-foot-tall statue of Gen. George Washington rests atop the Doric column made of granite. Below the statue, an observation deck, accessible by means of an elevator, provided tourists with a view of the city. Two bronze statues of Continental soldiers flank the entrance, and the base of the monument is adorned with three bronze plaques. The monument became part of Washington Crossing State Park in 1935, and in 1977, it was listed in the National Register of Historic Places. (AC.)

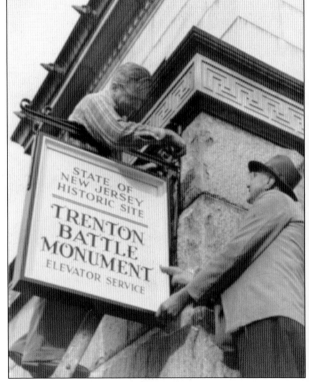

Two
Washington Crossing Historic Park, Pennsylvania

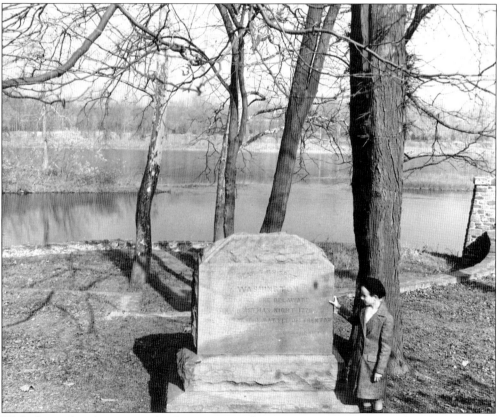

With the stroke of a pen on July 25, 1917, Pennsylvania governor Martin Brumbaugh signed into law an act "to authorize the acquisition, by purchase or condemnation, of land for a park and the erection of a monument commemorative of Washington crossing the river Delaware." This legislation set into motion what would result in the creation of the WCHP. A young girl gazes upon the monument erected in 1895 by the Bucks County Historical Society marking the spot where Washington and his army crossed the Delaware on Christmas night 1776. (BCHS.)

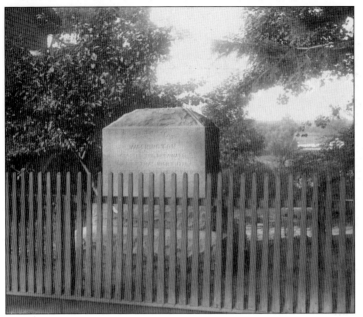

In 1895, the Bucks County Historical Society erected this monument to commemorate the spot of Washington's historic crossing. The monument was placed on the property of Sarah and Dr. Howard Griffee. The historical society purchased a small 100-square-foot plot from Dr. Griffee located in his front yard. The monument, made of Jersey brownstone and weighing 20 tons, sat within a picket fence that enclosed the yard. (BCHS.)

The monument seen to the far left was dedicated on October 15, 1895, with Dr. Howard Griffee's front porch serving as center stage. Nearly 500 people attended the ceremony. Reverend Dare from Titusville gave the invocation, and Gen. William Davis, the president of the Bucks County Historical Society, presided over the event with local children dressed festively and area school bands performing. Gen. William Stryker and Dwight Lowery were guest speakers. Bessie Twining unveiled the monument. (BCHS.)

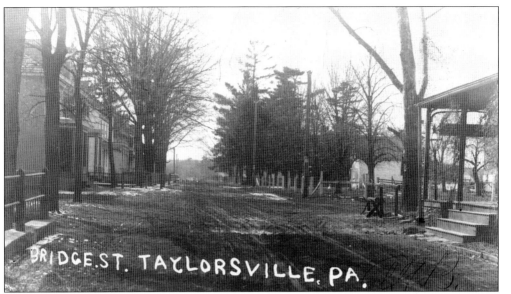

Bridge Street (Route 532) looking westward is pictured in this c. 1904 postcard. During the time of the crossing, this area was known as McConkey's Ferry, named after Samuel McConkey, who operated an inn and a ferry across the Delaware River. In 1777, Benjamin Taylor III purchased all the land along the river, which included the inn and the ferry. In keeping with the tradition of naming ferries after their operators, the area became known as Taylor's Ferry. (RAS.)

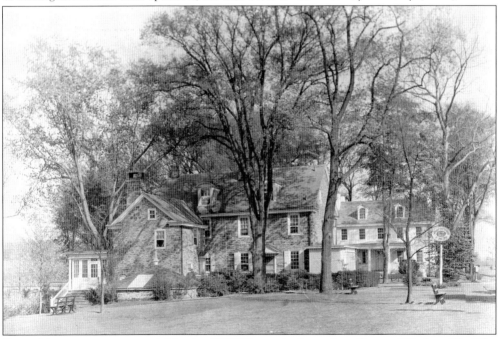

Several historic structures within the WCHP remain from the village of Taylorsville. The Taylor family created a self-sufficient community here in the early 1800s. The village contained a blacksmith shop, wheelwright shop, tailor, physician, general store, and post office along with several tenant houses. This c. 1930 image shows the back of the McConkey Ferry Inn and the front of the Mahlon K. Taylor House, built around 1817. (BCHS.)

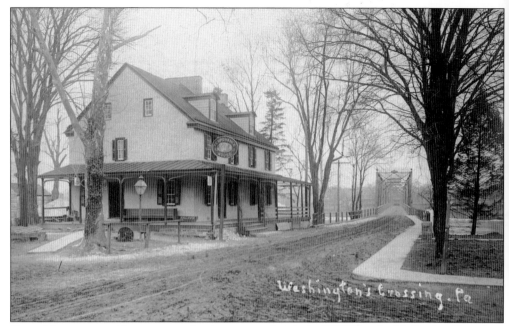

One of the most notable structures that is connected with the WCHP is the McConkey Ferry Inn, or Temperance House, as the sign above the porch notes in this c. 1910 image. The structure sits on the original site of the McConkey Ferry that was here during the time Washington and his army crossed the Delaware. Over the years, the building has gone by different names: McConkey Ferry Inn, Taylorsville Hotel, the Delaware House, Old Ferry Inn, Temperance House, and Lovett's Temperance House. (BCHS.)

Shown around 1906 is the east side of the McConkey Ferry Inn. Several theories have been proposed about its role at the time of the crossing. Architect George Edwin Brumbaugh, in the 1950s, proposed that the western portion of the inn was the only portion standing during the crossing. However, architect Jay Martin Rosenblum theorized that none of the building existed at that time but that log huts occupied the site instead. (BCHS.)

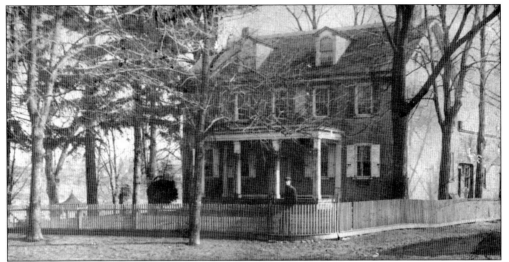

One of the stateliest structures within the WCHP is the Mahlon K. Taylor House, seen here around 1910. The home is located on the southeast corner of Washington Memorial Boulevard (Route 532) and Embarkation Drive, opposite the McConkey Inn. Built around 1817, the structure illustrates Taylor's successful career as a merchant and entrepreneur. It was the first and largest residence to be built in what would become Taylorsville. When the park took possession of the house, several frame additions built on the south side were removed. (RAS.)

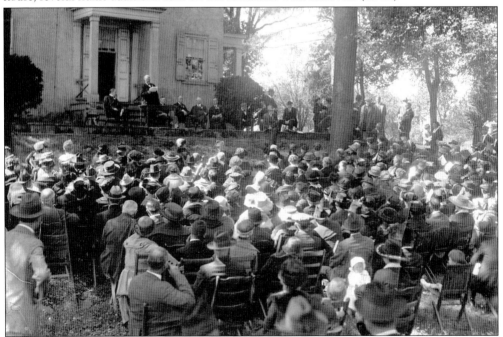

On October 1, 1921, the Washington Crossing Park Commission (WCPC) officially dedicated the Pennsylvania State Memorial Park. The day's festivities began with a flag-raising ceremony, while schoolchildren sang patriotic songs. A large gathering attended the formal program, which took place on the east lawn of the Mahlon Taylor House. Special presentations were given by local historians, members of the WCPC, and a Philadelphia common pleas judge. Tours of the park were given, and 50 schoolchildren enjoyed a ride on the Delaware in a Durham boat. (BCHS.)

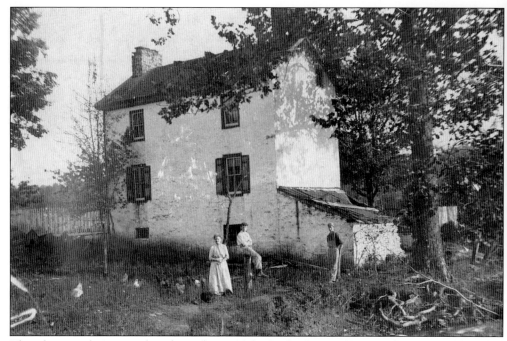

This photograph preserved in the archives of the Bucks County Historical Society is identified as "Old House at Taylorsville, 1900." This house is similar in size and architecture to the Abdon Hibbs House, John Frye House, Amos Taylor House, and Eliza Taylor House. These homes, known as "Taylorville Houses," were constructed around 1828–1830. They have similar front facades but contain other features that are unique to each house. These homes were built as residences for members of the Taylor family or rented to tradesmen and craftsmen. (BCHS.)

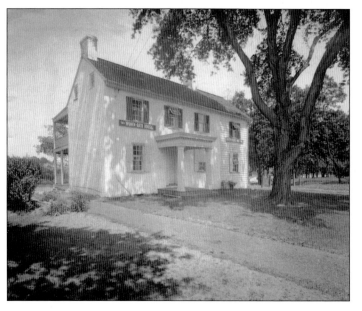

The Eliza Taylor House dates to about 1834 and is located on Embarkation Drive. The Taylor family lived in the home until 1842. In the 1920s, swimming in the Delaware became a popular activity. Three bathing beaches were opened along the shore of the park. Seen here in 1924, the house was renovated into a bathhouse with changing stalls for men and women. Future plans for the building are to renovate it as an environmental education center. (TFPL.)

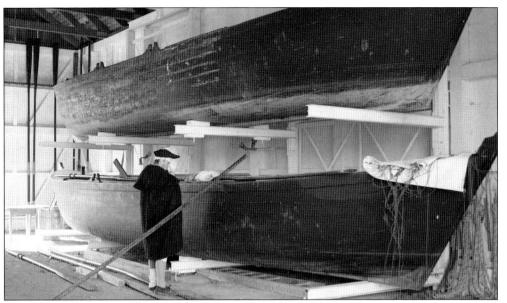

Seen here are two of the four replica Durham boats that are housed in the Durham Boat Barn, built in 1977. The design and location of the building are replicated from a photograph of the Society of the Cincinnati's monument on the New Jersey side looking west toward Pennsylvania (see page 46). The boats, which are owned by the Washington Crossing Foundation, are essential to the annual Christmas day crossing re-enactment. The first boat used in the annual re-enactment was constructed in 1965. (RS.)

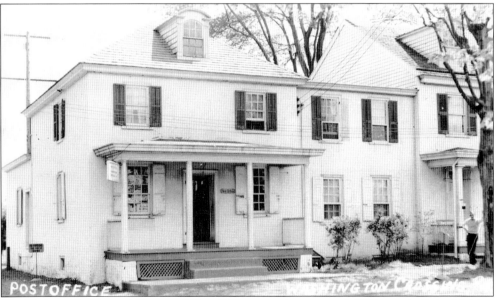

The Taylorsville General Store and Post Office, seen here around 1930, was built by Mahlon Taylor around 1824. Taylor operated the store and post office where he served as postmaster. In 1917, Congressman Henry Watson requested of the US postmaster general that the community's name be changed from Taylorsville to Washington Crossing; it became official in 1919. During World War II, the building housed the local chapter of the Red Cross. It operated again as a general store and snack bar after restoration in 1976. (BCHS.)

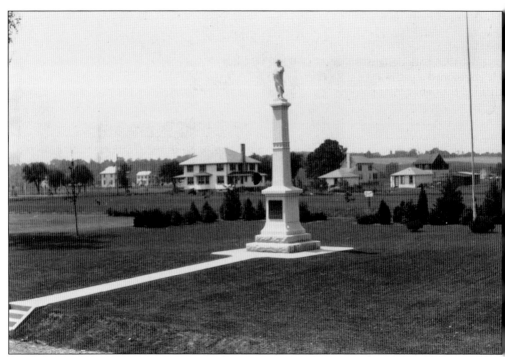

The George Washington Memorial, erected by the Patriotic Order Sons of America of Pennsylvania (POSAPA), was dedicated on May 27, 1916. In this c. 1920 photograph, the monument rests on the spot believed to be where Washington and his staff viewed the embarkation of his troops that historic Christmas night. The monument stands 35 feet high with a life-size statue of Washington atop its peak; two bronze plaques are affixed to the shaft. In 1958, the POSAPA turned the monument over to the state when the memorial building was erected. (BCHS.)

The main entrance into the Valley of Concentration, seen here around 1928, from River Road (Route 32) was created by architect Arthur Cowell. The sight is believed to be where Washington's troops formed and drilled before the crossing. Cowell envisioned the public to begin its visit here and then proceed to the Point of Embarkation following the route of the Continental Army. Six stone pillars flank the entrance. A 100-foot-tall flagpole was installed by John Longo and Son of Camden, New Jersey. (PHMC.)

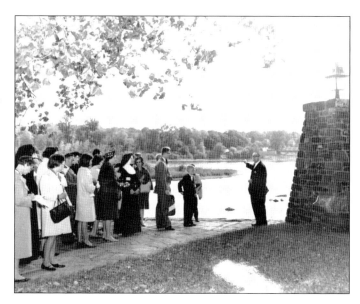

The Point of Embarkation, seen here around 1964, was one of Arthur Cowell's original 1926 park designs. He envisioned a pathway that led the public from the Valley of Concentration down a series of stone stairways to an oval-shaped landing flanked by two stone pillars topped with copper lanterns. Here visitors could stand along the river's edge at what is believed to be the spot where Washington's Continental Army crossed on Christmas 1776. (PHMC.)

In this 1920s photograph, a sign that reads "Washington Crossing Park" stands along the shoreline of the Delaware River. The sign was removed in 1925, when the seawall, seen to the left near the Ferry Inn, was extended north beyond the Point of Embarkation. It was completed in 1928 and included several stone stairways that led to the water's edge. At present, all the stairways have been closed off but can still be seen. (BCHS.)

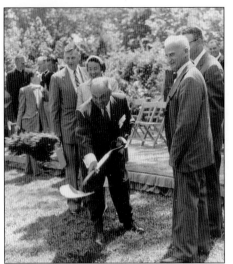

The ground-breaking ceremony for the new Washington Crossing Memorial Building was held on July 10, 1958. Pictured from left to right are Dr. Maurice K. Goddard, secretary of forest and water; Ann Hawkes Hutton, chairperson of the planning committee of the Washington Crossing Park Commission; A.J. Caruso, executive director of the Pennsylvania General State Authority, seen with a shovel in hand; E.J. Lever, chairman of the Washington Crossing Park Commission; and the master of ceremonies, Pennsylvania governor George M. Leader (hidden far right) who threw the first shovel of dirt. (WCF.)

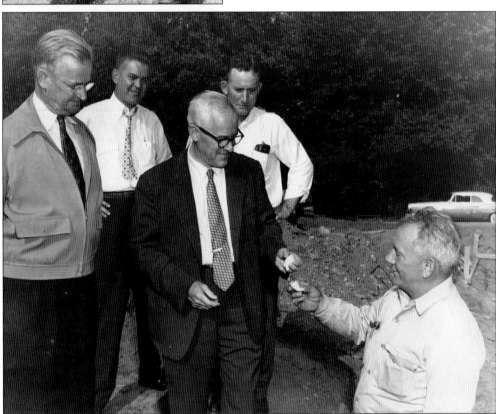

Before construction began on the new Washington Crossing Memorial Building and Visitor Center, archeological research was conducted on the site as seen in this November 1958 photograph. Several objects were discovered, like these pieces of clay pipes that were identified by state archeologist J. Duncan Campbell (seen center in dark suit) as the type commonly found at military encampments during the American Revolution. Campbell had participated in an earlier park archeological dig when test pits were excavated around the Thompson–Neely House, McConkey Ferry Inn, and Soldiers' Graves. (PHMC.)

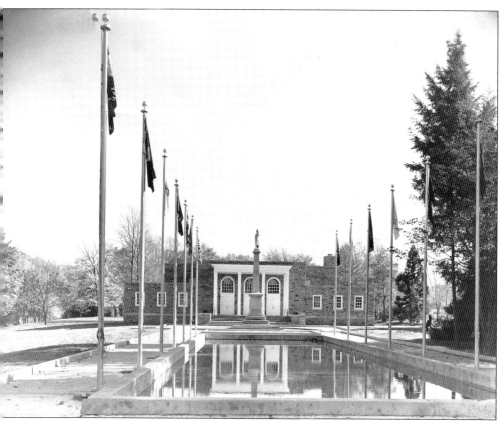

The Washington Crossing Memorial Building and Visitor Center is seen as it appeared around 1969. Constructed in 1959 of native fieldstone, its design was described in the dedication program as "modified colonial architecture" and is in the shape of a keystone in reference to the state's nickname. Dedicated on September 19, 1959, the building cost a reported $260,000. It contained a 383-seat auditorium, a lobby, library and office space, a service room, and a souvenir shop. In 2013, the building was completely renovated. (TFPL.)

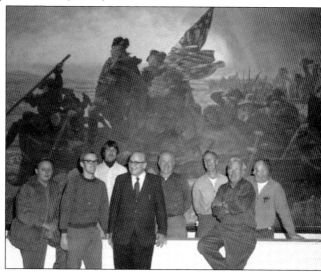

In this c. 1968 photograph, Washington Crossing Historic Park maintenance staff pose in front of the Leutze painting, displayed in the auditorium of the Washington Crossing Memorial Building. Pictured are, from left to right, Charles Mackey, two unidentified people, park superintendent E. Wilmer Fisher, Charles Wingate, Oliver Stark, Bill Johnson, and Bill Cooper. (BCF.)

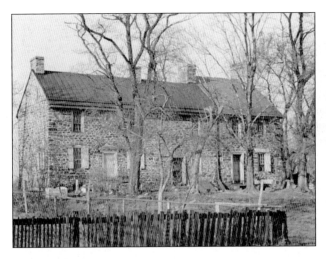

The Thompson-Neely Farmstead, shown here around 1900, served as one of Washington's military encampments during the winter of 1776–1777. The house and the grounds were transformed into a temporary regimental army hospital where many of the ill and injured soldiers were brought for medical treatment and recovery. James Monroe, who would become the nation's fifth president, recuperated here after sustaining serious injuries during the First Battle of Trenton, where he nearly died. (TFPL.)

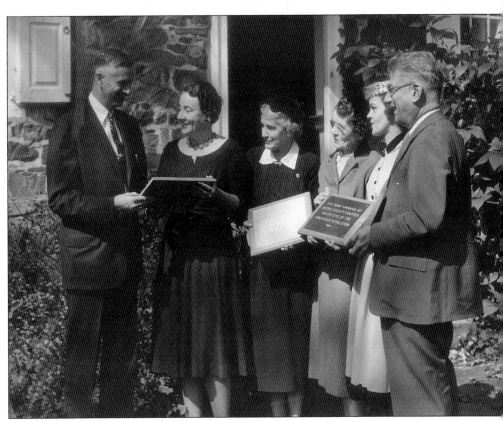

In the fall of 1946, architect George Edwin Brumbaugh was authorized by the park commission to restore the Thompson-Neely House. Restoration was completed in the summer of 1950. The interior provided space for formal presentations and exhibits. Period furnishings were provided by the Bucks County Daughters of the American Revolution, Bucks County Federation of Women's Clubs, Washington Crossing Park Commission, and Ann Hawkes Hutton. The house was officially dedicated on September 29, 1955. Pictured from left to right are Dr. Maurice K. Goddard, Ann Hawkes Hutton, and four representatives from the above-mentioned organizations. (WCF.)

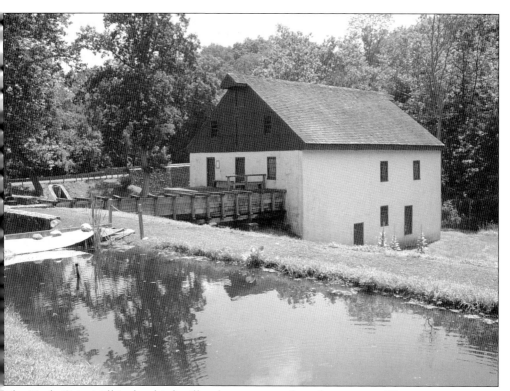

The Neely Grist Mill is the third mill to be constructed on the property. The present structure was built in 1875 by John Neely after a fire destroyed the previous structure in August 1873. The mill receives its water supply from the Pidcock Creek, which is carried swiftly through a race to drive the mill's wheel. The State of Pennsylvania purchased the mill in 1910; it sat silent until the 1970s, when it was restored to resemble a gristmill of the late 1820s. (AC.)

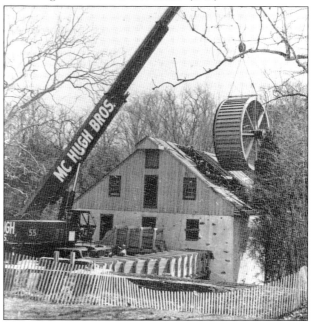

In April 1976, the Neely Grist Mill was fitted with a new 17-foot waterwheel. McHugh Brothers Heavy Hauling Company lifted the six-ton wheel through a hole cut in the roof. The hand-sawn wheel, made with wood from a 240-year-old white oak tree and cypress, took craftsmen at Paramount Industries four months to construct. Paramount also built a new mill flume and machinery in the interior of the mill. The mill was formally dedicated and opened to the public on June 5, 1977. (PHMC.)

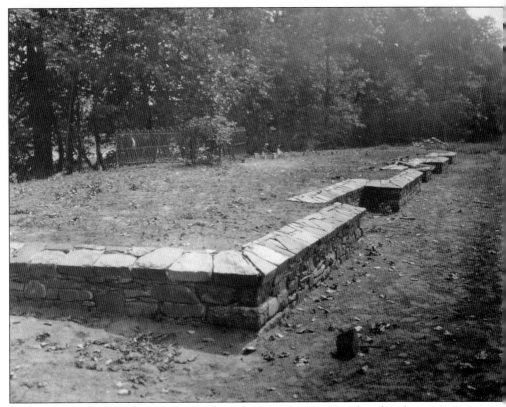

The Soldiers' Graves Memorial rests between the Delaware Canal and Delaware River, just a short walk from the Thompson-Neely Farmstead. Seen here around 1929, it is the final resting place of Capt. James Moore and several unnamed Revolutionary War soldiers. For many years, the graveyard fell into neglect. In the late 1920s, after the park gained possession of the property, the cemetery grounds were cleared of debris, and a stone retaining wall was built around the graves. The iron fence that once surrounded Moore's grave is noticeable atop the mound. (TFPL.)

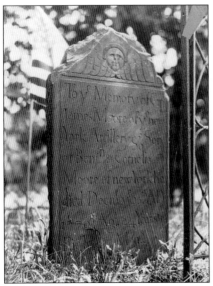

The original headstone of Capt. James Moore, the only identified veteran buried at the Soldiers' Graves Memorial, is pictured here. Moore died on the evening of the crossing. His headstone is inscribed, "To the Memory of Cap. James Moore of the New York Artillery Son of Benjamin & Cornelia Moore of New York He died Decm. the 25th A.D. 1776 Aged 24 Years & Eight Months." The headstone was replaced by a modern marker, and it is now in the WCHP's museum collection. An iron fence that once surrounded his grave was removed after 1930. (BCHS.)

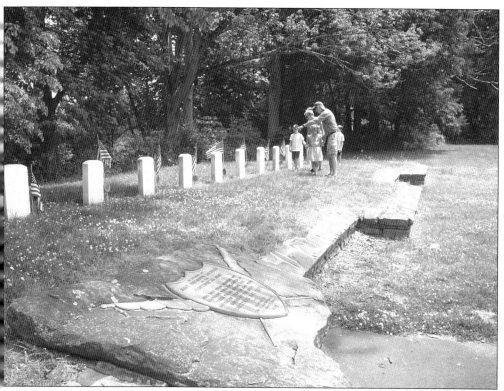

Visitors to the Soldiers' Graves Memorial walk among the markers of the final resting place of some 24 or more unnamed Revolutionary War soldiers. Only artillery captain James Moore's grave is identified. John Stillwell of Doylestown was commissioned to create a bronze plaque that is mounted on a large native boulder. The plaque reads, "In Memory of Many Unknown Soldiers Of the Continental Army Who died from sickness and Exposure while encamped in These fields before the Battle of Trenton and were Buried at this spot Christmas day 1776, Erected by The Commonwealth of Pennsylvania 1929." (AC.)

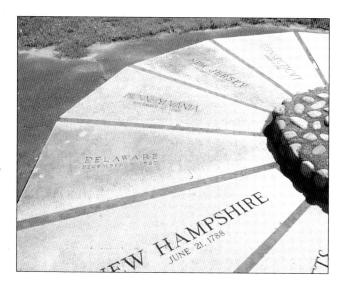

In 1930, a flagpole was installed at the Soldiers' Graves Memorial. Thirteen pieces of cut stone surround its base, each native to the state it commemorates and engraved with the date it ratified the Constitution. It took several years before the entire compilation of stone was complete. As the stones arrived, they were installed. On July 4, 1940, a special ceremony was held to dedicate the graveyard and flagpole. In 1941, the final stone arrived from Maryland, allowing for all 13 colonies to be represented. (AC.)

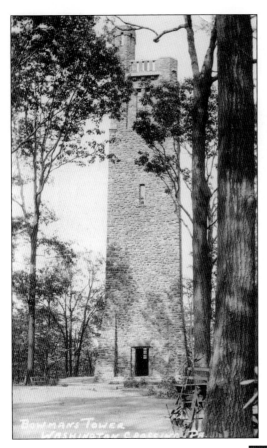

Bowman's Hill Observation Tower's construction began in 1929 and was completed in 1931; it was designed by landscape architect Arthur Cowell. The tower rises 125 feet in the air and offers a 14-mile view on a clear day of the Delaware River Valley. The hilltop on which the tower is constructed is rumored to have been used as a lookout point for General Washington's troops. Historians today believe this to be oral tradition more than recorded fact. (RAS.)

Construction on the Bowman's Hill Observation Tower began in 1929. The main structure is built of native stone from Bowman's Hill and area-stone fences. Stone cut for the sills and balustrades was from quarries located in Lumberville, Pennsylvania, and Lawrenceville, New Jersey. Over 2,400 tons of materials were used in its construction. To provide a solid foundation for the tower, the base was excavated 15 feet. When completed in June 1931, the total cost, including materials and labor, was $28,399.07. (TFPL.)

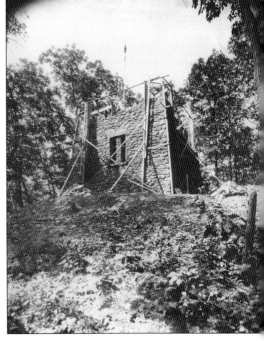

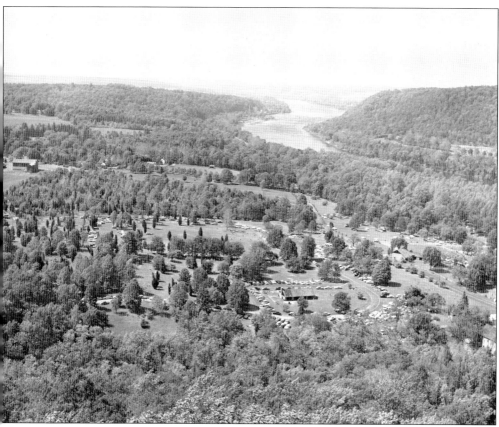

This c. 1950 view looking north from the observation deck of the Bowman's Hill Observation Tower shows the Capt. James Moore Picnic Pavilion at the Bowman's Hill Wildflower Preserve. A spiral cement staircase with a bronze handrail leads visitors to the observation deck. In the 1980s, an elevator was installed. Early discussions were to construct two observation towers, with one in each state park, but in the end, only Pennsylvania constructed a tower. (BCHS.)

A holiday tradition that has taken place for many years has been the lighting of a large five-point Christmas star atop the Bowman's Hill Observation Tower. Barbara Cooper Felver recounts that her father, Bill Cooper, who worked at the park for 38 years, designed and built the star. Seen here around 1958 are, from left to right, Bill Cooper, Leo Wiggins, Charles Wingate, Bill Holland, Charles Gunser, and Willett Hibbs. (BCF.)

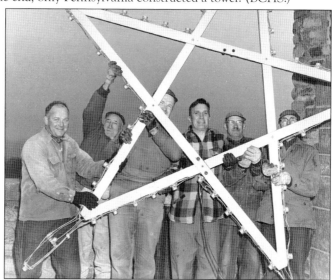

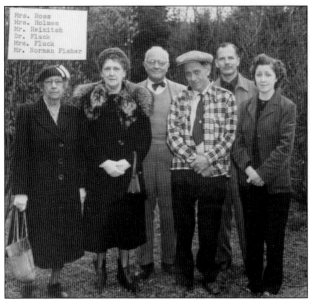

Members of the Bowman's Hill State Wildflower Preserve Committee are pictured here in 1953; from left to right are executive directors Cornelia Ross, Elma Holmes, and W. Wilson Heinitsh, botanist; Norman Fisher, general member; Paul H. Fluck, MD; and Jeanne P. Fluck. The wildflower preserve began as the vision of Mary K. Parry and W. Wilson Heinitsh. In June 1934, the Council for the Preservation of Natural Beauty in Pennsylvania was given 100 acres on Bowman's Hill by the park commission to establish a wildflower preserve. (POC.)

A 1962 rendering of the new Bowman's Hill Wildflower Preserve headquarters shows the design of the building, overseen by the firm of Ehrlich and Levinson of Philadelphia and built at a cost of $75,000. Dedicated on May 13, 1965, the new headquarters quickly became a success with a reported 33,000 visitors in 1966 and 69,000 in 1970. Today, the Bowman's Hill Wildflower Preserve continues to inspire the appreciation and use of native plants by serving as a sanctuary and an educational resource for conservation and stewardship. (PHMC.)

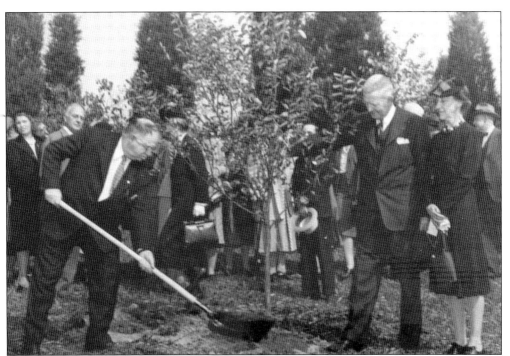

On April 22, 1947, Pennsylvania governor James Henderson Duff, standing right of the tree, participated in a tree-planting ceremony at the Bowman's Hill Wildflower Preserve. The preserve was honored with the Founders Fund Award from the Garden Club Federation of Pennsylvania that year. The preserve was designated as one of "the most outstanding horticultural or conservation projects in the United States." Pictured from left to right are Dr. Roscoe C. Magill, park superintendent; Governor Duff; and Margaret S. Zantzinger, chair of Penn's Woods Arboretum. (POC.)

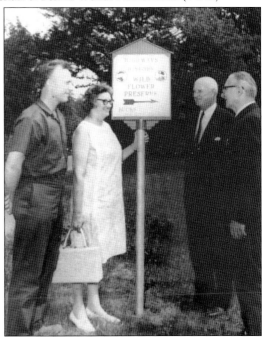

In the early 1960s, the Bucks County Historical–Tourist Commission began a program known as the Bucks County Highways of History. The program erected markers around the county promoting its tourist sites. Several markers were located within the park. This marker, seen on June 13, 1967, was placed for the Bowman's Hill Wildflower Preserve. Pictured from left to right are Oliver J. Stark, botanist; Edith B. Taylor, Bowman's Hill Wildflower Preserve chair; Al B. Chamberlain, director of the Bucks County Historical–Tourist Commission; and E. Wilmer Fisher, park superintendent. (PHMC.)

In the years between 1940 and 1950, the park constructed additional recreational facilities for both the lower and upper portions of the park. Due to the growing number of visitors and picnicking activities, several new picnic areas were developed, which included a large number of picnic tables and fireplaces built by park staff. Several of these areas provided picnic pavilions that could hold large groups at a time. These pavilions were given formal names, such as General Greene Picnic Pavilion, General Sullivan Picnic Pavilion, and Colonel Glover Picnic Pavilion. (POC.)

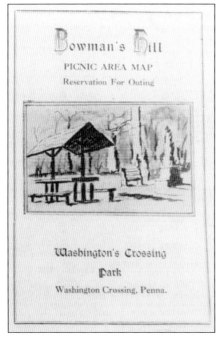

To accommodate the growing number of picnickers, the park printed this brochure, with artwork done by park superintendent Dr. Roscoe Magill on the cover. The brochure provided an application form so that visitors could reserve tables and pavilions. By the late 1950s, there were over 94 fireplaces, 150 picnic tables, and 1,000 benches in the park. Today, very few of these fireplaces remain. (POC.)

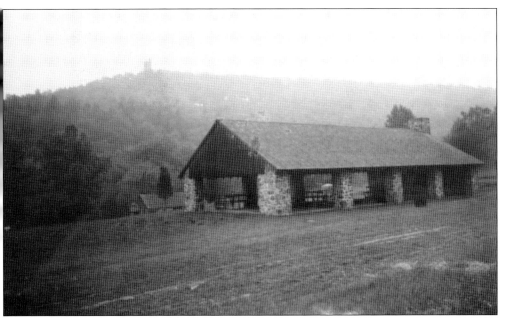

The Capt. James Moore Picnic Pavilion, pictured around 1944, sits at the entrance to the Bowman's Hill Wildflower Preserve. The idea of the pavilion was to provide a meeting place at the preserve and a retreat for visitors during inclement weather. Construction began in 1941 and was completed in the fall of 1942 at a cost of $500. The pavilion was built primarily by private donations. Materials and labor were provided by the park, and private funding, led by Ann Hawkes Hutton, was also supported by the local community. (PHMC.)

The General Sullivan Picnic Pavilion was constructed in 1953 by park staff at the point where the Pidcock Creek meets the Delaware River. The pavilion is named in honor of Gen. John Sullivan, who led a company of Washington's army en route to the Battle of Trenton in 1776. Located in the upper park, east of the Delaware Canal, the pavilion was the only one of four in the park that, at the time, was fully enclosed. It has since been opened up. (POC.)

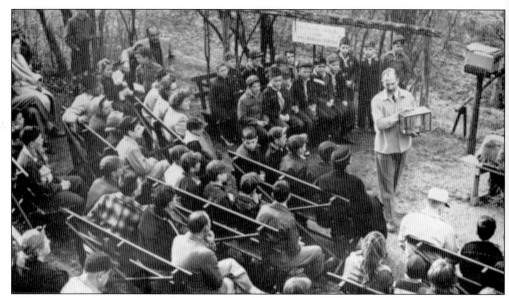

Dr. Paul H. Fluck, a Lambertville optometrist, leads a demonstration on bird banding. Dr. Fluck was the founder and manager of the Washington Crossing Park Bird Banding Station, which began in 1952. The demonstrations were given every Saturday and Sunday afternoon in an outdoor auditorium at the Victorian Neely House. The program became so popular that the Victorian Neely House was renovated to hold a small auditorium, laboratory, library, and darkroom. (BCHS.)

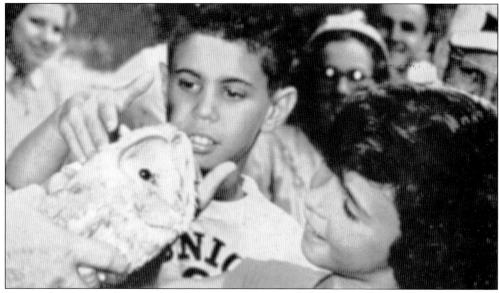

During the 1950s and 1960s, the Washington Crossing Park Nature Education Center and Bird Banding Station offered programs, nature walks, and classes. The most popular was Dr. Fluck's bird-banding demonstrations, which allowed children the opportunity to get close to the birds as with Barney, a blind barn owl. In 1959, the program drew 100,000 people to see 20,000 birds banded from 116 different bird species. The program appeared in several national magazines and won the Nash Conservation Award in 1956. (BCHS.)

Three
Washington Crossing State Park, New Jersey

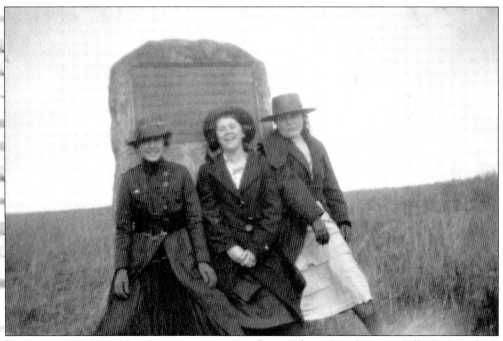

On January 22, 1912, New Jersey governor Woodrow Wilson signed Senate Bill No. 32, which allowed the newly formed Washington Crossing Park Commission to begin acquiring necessary lands to develop a park. An appropriation of funds was made by the legislature, and the first 100-acre tract was purchased. Dot Schmidt, pictured at left along with two friends, rests on the first monument that marked the crossing site, placed there by the Society of the Cincinnati in 1895. (RGM.)

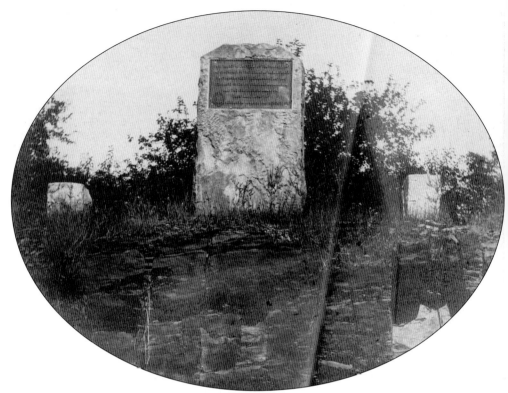

On October 15, 1895, the Society of the Cincinnati unveiled and dedicated the first monument to commemorate the spot where Washington and his army crossed the Delaware on Christmas night 1776 into New Jersey. The event was in coordination with the dedication of the Bucks County Historical Society's monument on the Pennsylvania side of the river. Local newspapers described the joint event as a "homemade celebration" performed in a "neighborly way." The monument was placed on a high ledge facing west toward the river and surrounded by four smaller stones. The Nelson family donated the property on which the monument was placed to the society. A bronze plaque was embedded into the large brownstone. In 1926, the monument was moved southward near its present location at the junction of Route 29 and Washington Crossing–Pennington Road. That location was near the planned park entrance. It was moved again in 1976 when the pedestrian bridge was constructed. Today, the monument sits inside the park gateway that was constructed in 1932. (Above, RGM; below, WCPAA.)

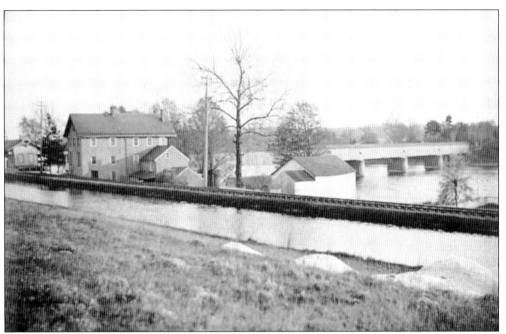

This photograph looks south along the Delaware & Raritan Canal feeder (D&R) to Washington's Crossing, New Jersey, around 1890. At the time of the Revolutionary War, this side of the river was known as Eight-Mile Ferry due to the distance from Trenton to the ferry crossing. In 1812, it was known as Bernardsville after Bernard Taylor, who then operated the ferry here until 1823. Pictured from left to right are the Belvidere Delaware Railroad (Bel-Del) passenger station and rail line, the Nelson Hotel and barns, and the Delaware River covered bridge, constructed in 1834. (JW.)

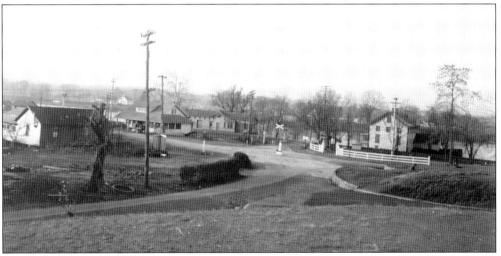

The intersection of Washington Crossing–Pennington Road and River Road is pictured here as it appeared in 1926. The image was taken near the newly constructed entrance into the Washington Crossing State Park (WCSP), seen at lower right. In 1851, the community once known as Bernardsville became known as Washington's Crossing. The change occurred when the Bel-Del Railroad line was created in the 1850s and the name "Washington's Crossing" was placed on the passenger station. Noticeable from left to right is an unidentified business, Leon Kent's Store, a passenger station, and the Nelson Hotel. (JW.)

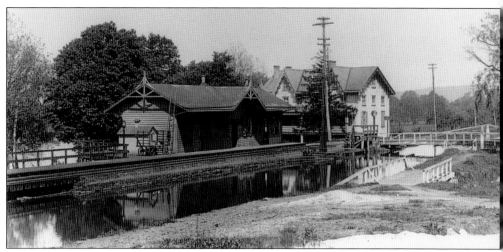

The Washington's Crossing station, pictured around 1910, was built as a stop along the Bel-Del Railroad. Built in the stick Victorian style, it stood on the west side of the D&R Canal feeder and across the street from the Nelson Hotel. After World War II, passenger service was dramatically reduced, and it ended in 1960. In 1976, the tracks were abandoned completely, and they were torn up several years later except for a couple of sections between Milford and Phillipsburg and between Lambertville and Stockton. (RGM.)

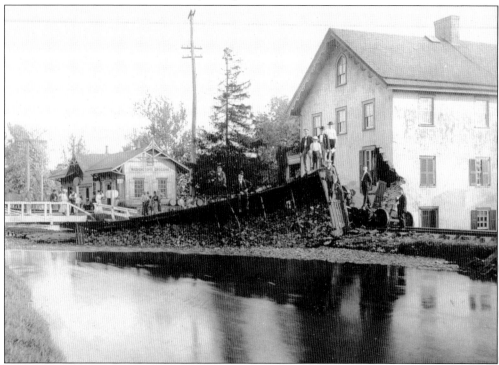

On May 27, 1904, the corner of the Nelson Hotel was seriously damaged when four freight cars derailed when an axle of one of the cars snapped. The train was headed south toward Trenton and was carrying stone at the time of the derailment. Two of the cars tumbled into the D&R Canal feeder, and another was sent spinning on the platform of the Washington's Crossing station. No one was injured during the accident, and service resumed several hours later. (RGM.)

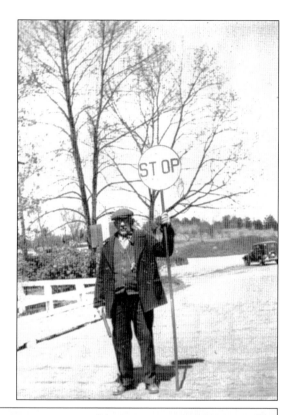

Morrisville resident Ellis Tettemer stands at the railroad crossing by Washington's Crossing station. Pictured in about 1930, he is listed in the 1930 US Census as a freight conductor. His duties, among other things, would have included securing railroad crossings for the safe passage of the train. The importance of this job is evident when on November 12, 1928, Dr. Raymond A. Leiby, a prominent New Hope physician, was killed by a speeding Bel-Del express train as his automobile passed over a grade crossing located between Titusville and Washington Crossing. (RGM.)

BUY TRIMMER PARK LOTS NOW!
500 ACRES UNDER DEVELOPMENT JUST NORTH OF
WASHINGTON'S CROSSING PARK

HIGH elevation, excellent view, always a breeze; above the river damp and fog; pure air and pure water; convenient to trains, bus, stores, churches, school, etc.; near the river, on the finest sheet of water for canoeing, boating, bathing and river sports on the Delaware; on the newly constructed river drive, 8 miles north of Trenton. Property in this section rapidly growing in value – buy before WASHINGTON'S CROSSING PARK is established. Lots 50 by 200 feet on 60 foot streets. Price, $200 and up; terms, $10 down and $10 per month. Immediate possession; a good place to live or to invest. For further information, apply

E. G. TRIMMER, OWNER AND DEVELOPER
TITUSVILLE, N. J.
BELL PHONE 157-R-4 PENNINGTON

In the years after World War I, Titusville and Washington Crossing became popular summer resorts for many Trentonians. Edward G. Trimmer saw the opportunity to post this notice advertising the sale of lots on the "newly constructed river drive." This new road east of the feeder canal would become today's New Jersey Route 29. Prior to this time, Route 29 was no more than a lane; the main road went through the village of Titusville. The new road eliminated three dangerous railroad crossings and canal crossings. (RGM.)

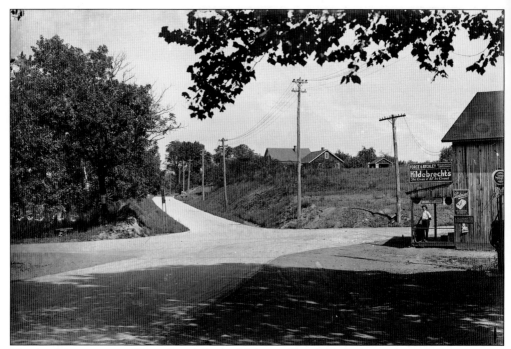

The northeast corner of River Road, Route 29 (center), and Washington Crossing–Pennington Road, Route 546 (right), is seen here around 1910 prior to the construction of the main entrance into the WCSP. In 1913, the State of New Jersey began the process of land acquisitions that were required to create the park. On April 30, 1926, the state acquired the two homes seen on the hilltop from Kate and Willard Johnson (left) and Flora and Harvey Nason. (HVHS.)

This November 22, 1926, image of the northeast corner of River Road (Route 29) and Washington Crossing–Pennington Road (Route 546) shows the completion of the main entrance and pedestrian staircase leading into the park. The three homes that once stood on the hilltop Kimble, Johnson, and Nason properties had been removed by that May. After the removal of these homes, construction on the plaza, or "crossing overlook," began. (JW.)

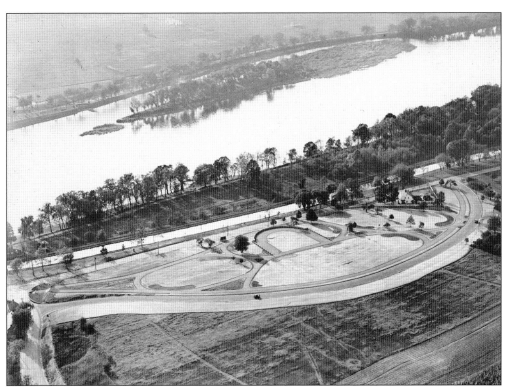

This aerial view of Washington Crossing State Park in October 1926 was taken by Virgil Kaufman's Aero Service Corporation, which was known for a wide variety of projects, including aerial photography, photograph mapping, and remote sensing. Visible are the new entrance into the WCSP, seen at far left; the crossing overlook; the Johnson Ferry House, seen to the right; and Taylor's Island, within the Delaware River. (NJSA.)

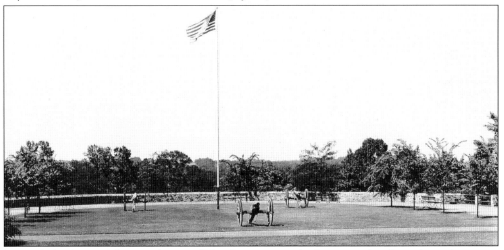

In 1926, the Sons of the Revolution of New Jersey erected a large wooden flagpole in the center of the plaza to mark the 150th anniversary of the crossing. A plaque attached to the pole read, "Presented To Washington Crossing Park By The New Jersey Society Sons of the Revolution, December 26, 1926." Eventually, the weather took its toll, and the pole was removed. The plaque that wrapped around its base is today exhibited in the park's Visitors Center Museum. (WCPAA.)

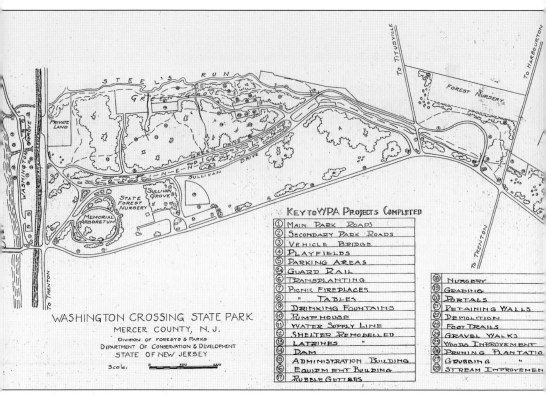

The Works Progress Administration (WPA) was the most ambitious of the New Deal programs enacted by Pres. Franklin Delano Roosevelt in 1935 to ease the mass unemployment of the Great Depression. The majority of the WPA projects created infrastructure, as can be seen here in this 1936 map of the WCSP. In the 1930s, between $200,000 and $400,000 was spent in the park to build roads, dams, picnic pavilions, play fields, and bridges; many are still used today. (NJDPF.)

Construction began in 1929 of Sullivan Drive, seen here, as one of the public access roads into the interior of the park. The road was cut from a former farm field that paralleled Continental Lane. The road extended east from the Johnson Ferry House to where Brickyard Road met County Route 546. Agabiti Brothers of Trenton was hired to blacktop the road at a cost of $1.45 per square yard; the entire job would cover 10,000 square yards. A speed limit of 20 miles per hour was posted in 1930. (WCPAA.)

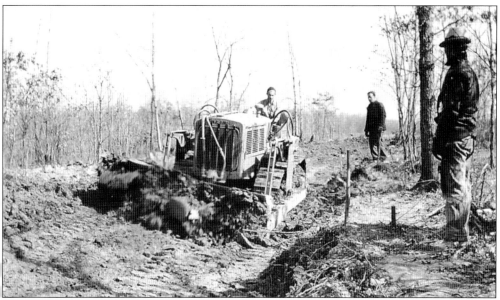

The construction of Greene Drive, seen here, did not begin until the arrival of the WPA workforce in 1935. This new road allowed vehicles to travel west toward the Johnson Ferry House and return by way of Sullivan Drive. The road was completed in the summer of 1936. Both roads were designated as one way with Continental Lane between them. (WCPAA.)

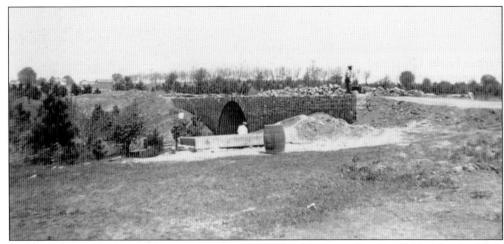

Construction on the Honeymoon Bridge began in 1935 and was completed in 1936 under the WPA program. The stone arch bridge, which crosses over Steel Run at the southeastern corner of the park, was once one of the main entrances into the park from Washington Crossing–Pennington Road. The bridge was constructed on a Concan steel arch manufactured by the Republic Steel Corporation in Cleveland, Ohio. A plaque was placed on the southeastern abutment of the bridge in 1937 recognizing the efforts of the WPA. It is unknown how the bridge was given its name. (WCPAA.)

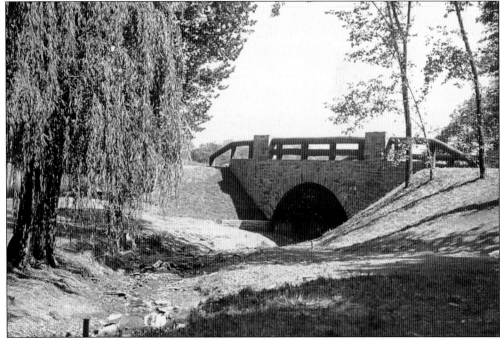

The Greene Drive bridge, east of Greene Grove, crosses over Steel Run and was the second bridge to be constructed by the WPA in 1935. Its design is typical of the rustic "Parkitecture" style of architecture developed at this time by the National Park Service through its efforts to create buildings and bridges to harmonize with the natural environment. The design of the bridge is similar to that of the Honeymoon Bridge; they both are constructed with a stone culvert on a steel arch. (WCPAA.)

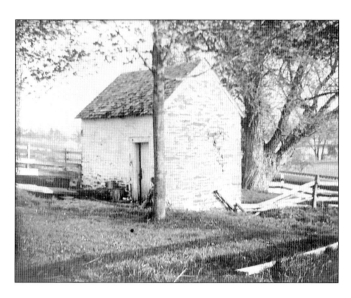

The Spring House, seen here around 1890, is located between the Delaware & Raritan Feeder Canal and New Jersey Route 29. It is the only outbuilding associated with the Johnson Ferry House and farm. It was initially used as a milk house; the cold spring water running over the milk containers worked as refrigeration to keep the milk cool. It later served as a pump station, drawing water from the feeder canal to the WCSP's nursery and fields across from Continental Lane. (JW.)

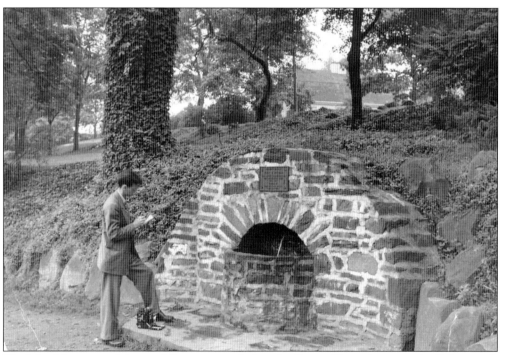

The John Honeyman Memorial Fountain sits below the Spring House between the Delaware & Raritan Feeder Canal and New Jersey Route 29. The fountain, which is connected to a running spring, was erected by the Patriotic Order Sons of America of New Jersey in 1930. Honeyman, believed to have spied for Gen. George Washington, is credited with helping to lead the Continental Army to achieve victory over Rall's Hessians in Trenton. (WCPAA.)

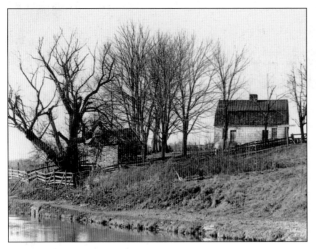

The Johnson Ferry House is the oldest and most historic structure within the WCSP. Built about 1740 by Rutger Jansen (or Johnson), the home was part of a 500-acre parcel of land that was later farmed by son Garrett, who also operated a ferry service across the Delaware River. The farm and ferry were sold in 1770 to Abraham Harvey, who then rented the property to James Slack. Slack operated the ferry on the night of the famed crossing and would continue operating the New Jersey ferry until the 1780s. (NJSA.)

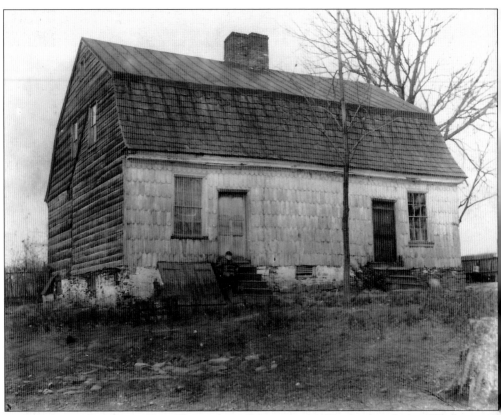

For many years, the Johnson Ferry House, shown here around 1910, was identified as "Washington's Headquarters." Although Washington may have taken a brief respite there after his harrowing crossing on the icy Delaware, it was never used as his headquarters. For many years, the building's name had been disputed. It was once believed that William McConkey owned the building and hosted Washington and his officers on the night of the crossing. After many years of debate and research, this Dutch American farmhouse is officially known as the Johnson Ferry House. (WCPAA.)

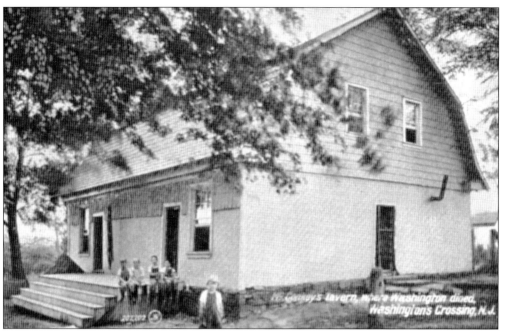

In 1903, Dr. Isidor Strittmatter, a prominent surgeon from Philadelphia, purchased the ferry house at a sheriff's sale. The building, which had been unoccupied since the late 1850s, had fallen into disrepair. Strittmatter replaced the tin roof with wooden shingles and refitted several rows of scalloped shingles on the facade, and he built a front portico on the south side of the house. In 1922, the State of New Jersey purchased the ferry house and its grounds from Dr. Strittmatter and incorporated them into the park. (TFPL.)

The Johnson Ferry House was formally opened to the public in 1926. It was initially recommended that the building be demolished and a replica rebuilt. The house contains nine rooms, half an attic, and a full basement. The keeping room, parlor, pantry, and bed chamber are furnished with period furnishings. Jessie Bronson Howell Field, seen in this c. 1945 photograph wearing a white dress, lived and served as a resident caretaker in the house from 1940 until her passing in 1955. (NJSA.)

Jessie Bronson Howell Field (lower right) poses with guests from Ohio in front of the Johnson Ferry House. Described as "hostess and curator," she began her duties on January 1, 1940, and served until her passing in October 1955. She meticulously kept a daybook where she noted attendance, weather, national events, and poems she would write about the house and the groups of schoolchildren who visited. One inquisitive schoolchild asked if she was George Washington's mother. (WCPAA.)

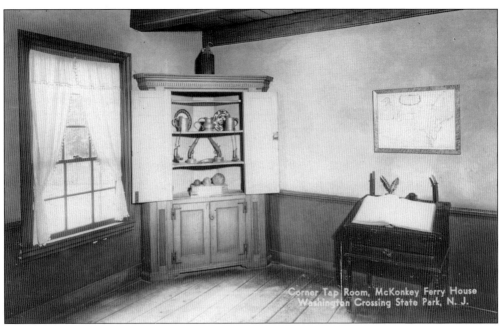

The Tap Room of the Johnson Ferry House is seen here as it appeared after extensive renovations by the Department of Conservation and Development (DCD) and reopening to the public in 1926. It is believed that New Jersey governor Arthur Harry Moore was the first to sign the guest register, seen open atop the desk on October 26, 1926. Antique furnishings were donated by both Dr. Isidor Strittmatter and Dr. Ida M.C. Hobensack. (RAS.)

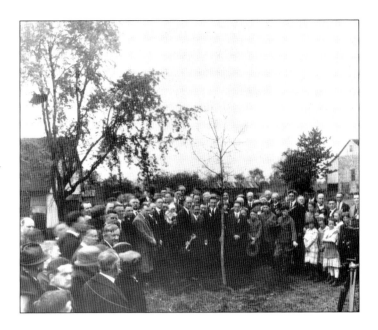

In a driving rain on April 22, 1927, thirteen American elm trees were planted near the Johnson Ferry House, with each representing one of the original colonies. The trees were a gift from Charles Lathrop Pack, president of the American Tree Association, of Washington, DC. The New Jersey tree was placed in the center of the grove. In attendance were representatives from the DAR, the Trenton Historical Society, and the Girls and Boy Scouts. (NJSA.)

New Jersey governor Arthur Harry Moore (fifth from left) along with other state officials poses in front of the Johnson Ferry House after the dedication of the George Washington Memorial Arboretum on May 19, 1932. Labeled as "A Gift to the People of the State of New Jersey," over 2,500 native trees and shrubs were planted throughout eight acres of the park by Charles Lathrop Pack and son Arthur Newton Pack in commemoration of Washington's 200th birthday. (NJSA.)

In the spring of 1925, the General Society of the Daughters of the American Revolution donated the resources to construct a formal garden behind the Johnson Ferry House. Landscape architect Edith Ripley Kennaday created a colonial garden resembling ones found at George Washington's Mount Vernon. It contained boxwood-lined pathways, fruit trees, bushes, and a grape arbor. The final touch was a handsome sundial, which remains there today. In 1987, the formal garden was transformed to reflect a traditional colonial kitchen garden. (WCPAA.)

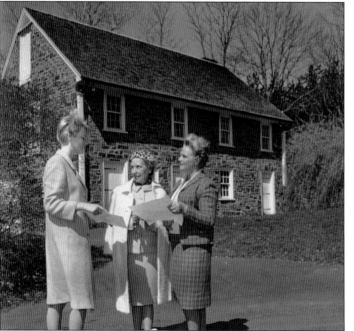

Pictured around 1969, Washington Crossing Association members Tia Boyan (left), unidentified, and Johanna van Dommelen (right) stand in front of the Harvey Stone Barn, located across from the Johnson Ferry House. Believed to have been built in the 1780s by the Harvey family, it is one of two outbuildings that remain from the 18th century. In 1930, the structure size was changed and reconfigured. It has served as a flag museum and houses a 24-foot-long diorama of the Christmas crossing made by David Lewis. (WCPAA.)

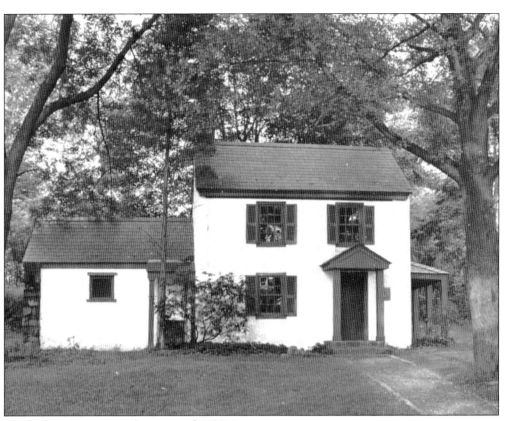

The Nelson House, seen here around 1980, is a 19th-century building that faces the Delaware River. The original construction date for the building has been debated by historians for decades. In 1846, Alexander Nelson purchased the house and grounds. Later, several additions to the structure created the Nelson Hotel. In June 1924, the State of New Jersey purchased the property from the remaining Nelson heirs. What remains today is believed to have served as the kitchen and icehouse. (WCPAA.)

Park interpretive specialist and historian Nancy Ceperley helps a young guest pick a souvenir flag around 1985 at the Nelson House. In 1980, the building was renovated by the first iteration of the Washington Crossing Association. The renovations included removal of the floorboards on the first floor, restoration of the original kitchen, filling the basement in with sand, and stuccoing and painting the exterior. Today, the Nelson House serves as a hospitality house for displays and historical interpretation. (WCPAA.)

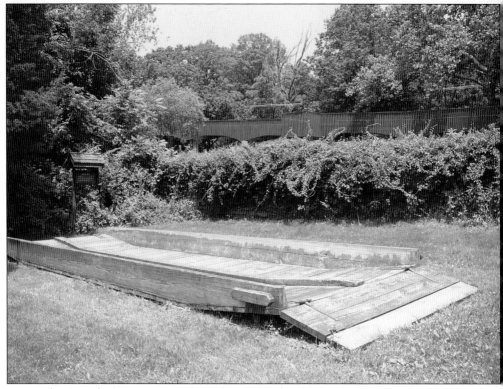

A reproduction of a ferry scow sits along the north side of the Nelson House as part of the park's interpretive programs. Built in February 2001 by Tom Carter, Benjamin Sanchez, and Jeffrey Noden, it replaced a previous ferry built in 1976 by Mitchell Carter that had weathered with time. Seen here is the pedestrian walkway constructed in 1976 that allows visitors to cross safely over Route 29. Its 1970s architectural design is ADA compliant and allows a wonderful scenic overlook of the river. (AC.)

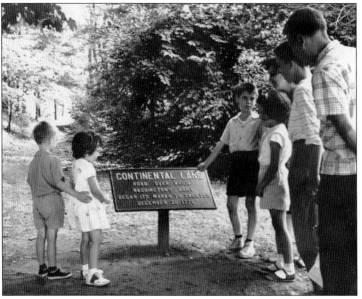

A family visiting the WCSP in about 1958 stops to read the sign marking the entrance to Continental Lane. Located behind the ferry house, it is believed Washington's army used this farmers' lane that runs through the park to Bear Tavern Road to begin the nine-mile march to Trenton. The lane is not without its controversies with historians but did play a role in determining what properties the state acquired to create the park. (WCPAA.)

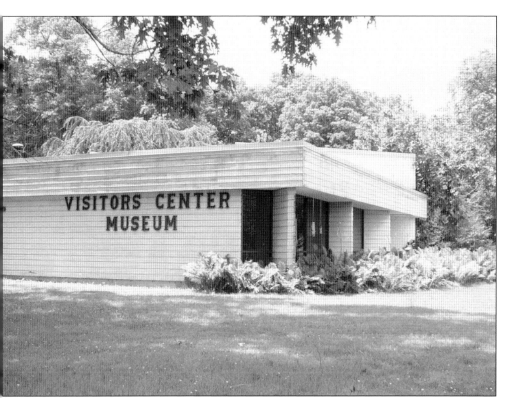

The Visitors Center Museum of the WCSP, seen here in July 2021, is located within the park off of Sullivan Drive. Construction on the $280,000 center began in late April 1976, and it was open to the public on September 11, 1976, with an official dedication on December 25, 1976, by Gov. Brendan Byrne. This date marked the 200th anniversary of Washington's historic crossing of the Delaware. (AC.)

Harry Kels Swan, pictured here in about 2011, was the historian and curator at the WCSP Visitors Center Museum from 1976 to 2002. An avid collector since the 1940s, his nationally recognized Revolutionary War collection became the core of the exhibits at the museum. When he loaned the collection to the State of New Jersey in the 1980s, he remarked, "I'm only the curator of it. It really belongs to the people." Swan created the Swan Historical Foundation in 1989 and served as its president. (WCPAA.)

Two unidentified young girls explore the nature trails in the WCSP in 1971. The first trail system was created by the WPA workforce in the late 1930s. Added to over many years by park employees, the trails were surveyed by the Youth Conservation Corps in 1979 and renamed with color codes. Among others, the red-, yellow-, and green-dot trails now loop through 13 miles of the WCSP's mixed hardwood forests. (NJSA.)

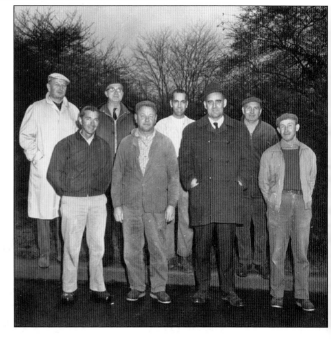

WCSP staff gather to pose for this image on December 19, 1961. Pictured from left to right are (first row) Raymond Barnhart, Walter Mariarz, Dirk Van Dommelen, and Norman Bradley; (second row) George Blaskovitz, Malcolm Joiner, Donald Maguire, and Carlton Foree. (NJSA.)

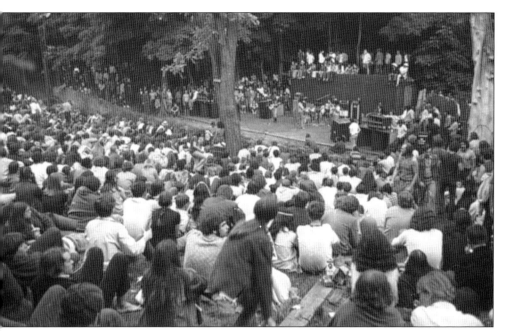

The Open Air Theatre, located above Steel Run in the WCSP, was created in 1964. Seen here around 1970, it became a popular summer attraction. Local residents and park staff recognized the natural amphitheater after heavy rains in 1962 destroyed a WPA dam on the creek, which runs between the audience and the stage. Bulldozers removing greenery to make repairs revealed the site. Park superintendent Dirk Van Dommelen, accustomed to attending outdoor theaters in his native Holland, began the decades-long run to promote live music and stage performances. (WCPAA.)

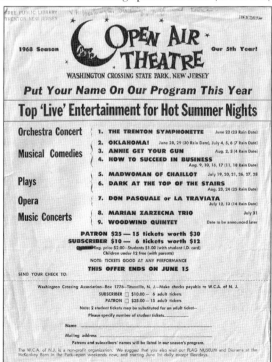

A copy of the 1968 season Open Air Theatre program lists the various scheduled performances in the WCSP. From its beginnings in 1964, visitors enjoyed historical orations, classical music, rock concerts, and theatrical plays performed by, among others, the Pennington Players. The theater was promoted by the Washington Crossing Park Citizens Committee, which was headed by Titusville resident Mitchell Carter Jr. and made up of prominent citizens, local politicians, and the park superintendent. (TFPL.)

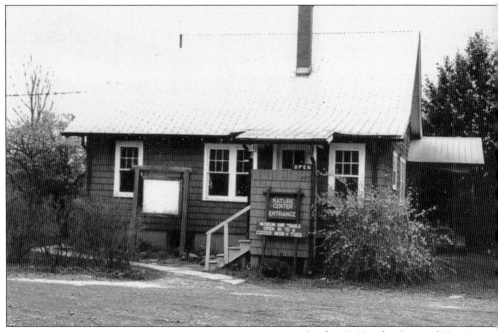

In the 1960s, the State of New Jersey purchased the property and former residence of George and Elizabeth Burkert. The building was converted into a nature center and opened to the public in 1967 in partnership with the Nature Committee of the Washington Crossing Association. For years, it served as a natural history interpretive facility and functioned as a wildlife rehabilitation center. In 1997, a new facility was constructed and was named the Interpretive Center. (WCPAA.)

British naturalist and nature artist Rachel S. Horne, pictured here with a fawn and schoolchildren in the 1970s, operated the WCSP's nature education center for nearly two decades. She led educational programs and tours through the miles of the park's nature trails, which drew 22,000 visitors in 1977. Horne also managed the wildlife rehabilitation program. For over 10 years, visitors came to see a disabled great horned owl named Mr. Hoot who lived on the back porch of the center. (NF.)

In 1961, about the same time this photograph was taken, the New Jersey Green Acres Open Space Land Conservation Program was created. The goal of the program was to preserve the amount of outdoor and recreational land through the sale of bonds that had been authorized by the state legislature. Through this program, the WCSP doubled in size from 372 acres in 1963 to 848 acres in 1978. This program allowed the purchase in 1962 of Phillip's Farm, where over 50 rustic campsites were created. Today, only four campsites remain. (WCPAA.)

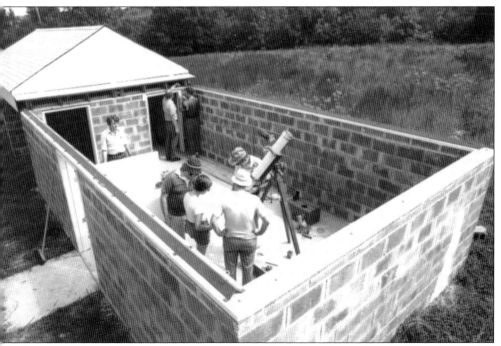

The Princeton Amateur Astronomers Association observatory, located in the WCSP, is a slide-roof design and allows for optimal viewing of the sky. Constructed in 1977 under agreement with the State of New Jersey, the John W.H. Simpson Observatory currently houses a Hastings-Byrne 6.25-inch optical refracting telescope. In 1979, the association boasted 150 guests and eight public star parties. Pictured in 1978 from left to right are Doug Wurzler, Bill Phillips, Kurt Goepfert, Dick Peery, Roxanne Peery, John Church, and Leith Holloway. (PAAA.)

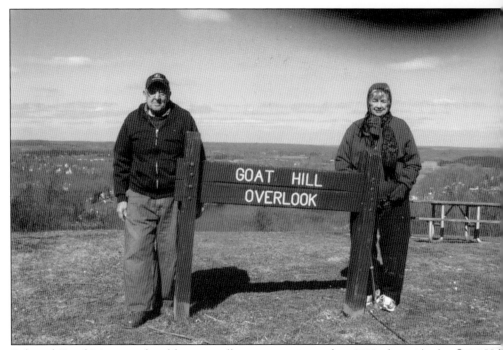

Bob and Carol Meszaros, local history collectors, are pictured in 2013 alongside the Goat Hill Overlook sign in West Amwell Township, New Jersey. According to legend, General Washington visited the site prior to the Battle of Trenton to assure the boats to be used for the Christmas crossing were well hidden from the British and local Tory sympathizers. One prominent rock outcropping on the hillside has long been referred to as "Washington's Rock." Hiking trails lead to a 150-foot-wide cleared area that provides a panoramic view of the Delaware River while looking north. (RGM.)

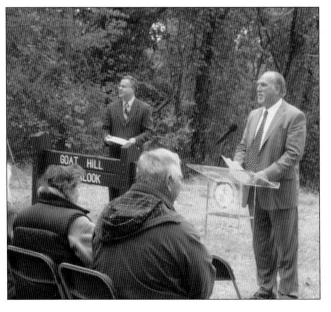

On October 14, 2009, acting commissioner of the Department of Environmental Protection Mark N. Mauriello, seen at the lectern, and Deputy Commissioner Jay Watson, foreground, participate during the dedication ceremony at Goat Hill, marking the acquisition of 213 acres by the State of New Jersey that became part of the WCSP. From the late 1800s to the 1930s, the site was the Goat Hill Quarry. In 1964, the land was donated by the McIntosh family to the Boy Scouts, and it served as the George Washington Scout Reservation into the 1980s. (DEP.)

Four

The Painting, Emanuel Leutze's Masterpiece in Art and History

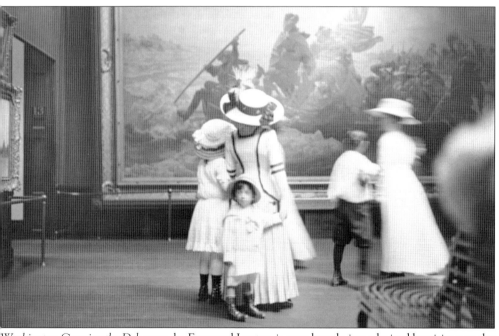

Washington Crossing the Delaware, by Emanuel Leutze, is seen here being admired by visitors at the Metropolitan Museum of Art in 1907. This 1851 masterpiece is perhaps the most representative of all the American ideals from the spirit of the Revolution—courage, independence, and patriotism. The painting was added to the Metropolitan's collections in 1897 and has had many homes in its 170-plus years. It was rehung in the American Wing of the museum in 2011 after being restored to its original grandeur. (MET.)

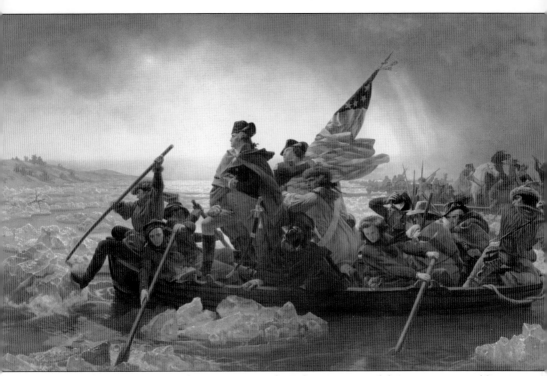

Emanuel Leutze's 1851 *Washington Crossing the Delaware* is one of the most recognizable paintings in the world. Although it was painted in Germany to inspire German reformers, it has become an iconic symbol of American patriotism. Measuring 12 feet 5 inches by 21 feet 3 inches, it is the second version; the first painting was destroyed by an Allied bombing raid during World War II. When first shown in New York in 1851, over 50,000 people attended the exhibition. The *New York Evening Mirror* declared the work "the grandest, most majestic, and most effective painting ever exhibited in America." Leutze arranged the figures in a triangular composition and purposely included a cross-section of the American colonies: farmers, a Scottish immigrant, an African American, a Native American, a western frontiersman in a coonskin cap, and a hatless man in a red shirt that may represent a woman. Holding the flag is Lt. James Monroe, future US president, as Washington postures as the hero of the scene. Criticized at times as historically inaccurate—noting the incorrect flag design, the size of the boats, and Washington standing in the boat—the painting was most importantly created to inspire, as it continues to do today. (MET.)

A c. 1843 self portrait of Emanuel Gottlieb Leutze is among the artwork of Georgetown University's Booth Family Center for Special Collections. Born in Germany in 1816, Leutze came to the United States as a child. He spent his early years in Philadelphia working as a draftsman and portraitist before returning to Germany in 1841 to study his craft. Many of his works depict events based on American history. His 1851 creation *Washington Crossing the Delaware* is arguably his best-known work. (GU.)

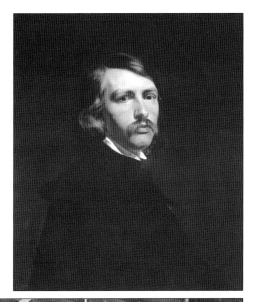

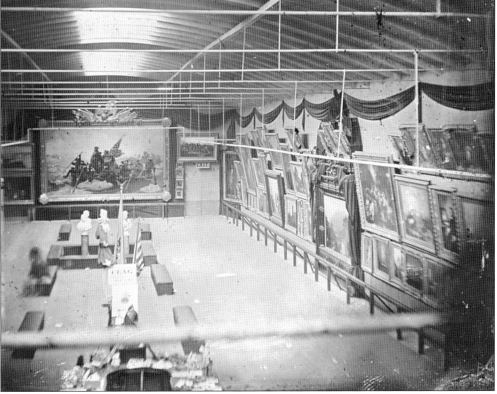

The Picture Gallery at the Metropolitan Fair was held at the 22nd Regiment Armory in New York City from April 4 to 23, 1864. Three hundred sixty works of fine art were featured. Emanuel Leutze's 1851 *Washington Crossing the Delaware* was a major attraction. It was on loan by its owner, Marshall O. Roberts. Emanuel Leutze had served on the fair's artists committee. Admission and merchandise sales raised $1,340,050.37 for the US Sanitary Commission in support of the Union army during the American Civil War. (AC.)

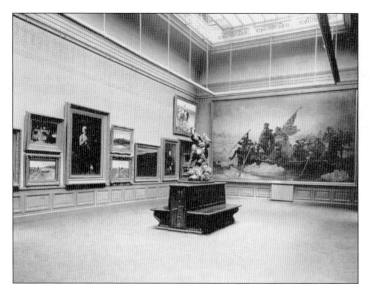

Washington Crossing the Delaware is shown covering the entire gallery wall in the Morgan Wing of the Metropolitan Museum of Art in 1918. For years, the museum struggled for the right placement of the gigantic piece as its collections continued to grow. Over the years, the painting fell out of favor with art historians and critics alike. It was always a crowd favorite, however, and remained in place for 30 years. (MET.)

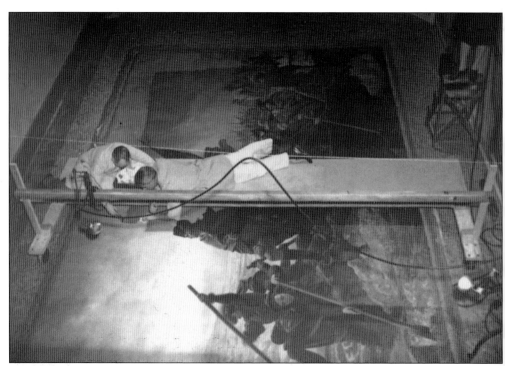

Murray Pease and Patrick Staunton of the Technical Laboratory at the Metropolitan in 1947 painstakingly remove years of dirt and discolored varnish from *Washington Crossing the Delaware*. The painting had been moved to the American Wing of the museum and then to the main hall. The team worked feverishly to complete the conservation and rehang the painting by Washington's birthday, February 22, 1947, so as not to upset the public—who continued to visit the painting in record numbers. (MET.)

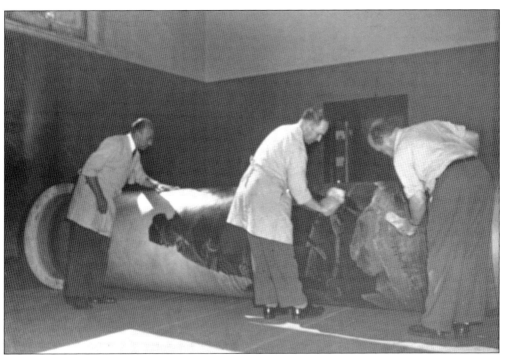

In 1950, the Metropolitan's conservators prepare *Washington Crossing the Delaware* for loan to the Dallas Museum of Fine Arts for display at the Dallas State Fair. It was unstretched and rolled onto a drum for shipment. During just two weeks in October in Dallas, over 100,000 people came to view the painting. The much-publicized loan caught the attention of Pennsylvania's Washington Crossing Park Commission, which set into motion almost two decades of loan negotiations, spearheaded by Ann Hawkes Hutton, to keep the painting at the Pennsylvania park. (MET.)

On the snowy day of February 14, 1952, Emanuel Leutze's painting *Washington Crossing the Delaware* arrived at the train station in Trenton, met by park commissioner Ann Hawkes Hutton and Metropolitan Museum conservator Murray Pease. Hawkes Hutton worked tirelessly to secure a two-year loan from the museum, with options to renew, and arranged for the painting to be hung at the Washington Crossing Methodist Church until a proper exhibition gallery could be built. "It's coming home," Hawkes Hutton remarked to a reporter from the *New York Herald Tribune*. (MET.)

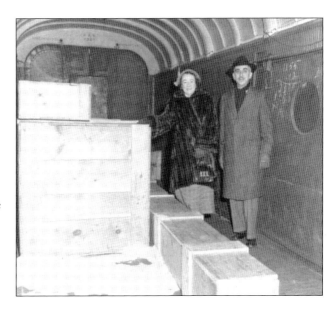

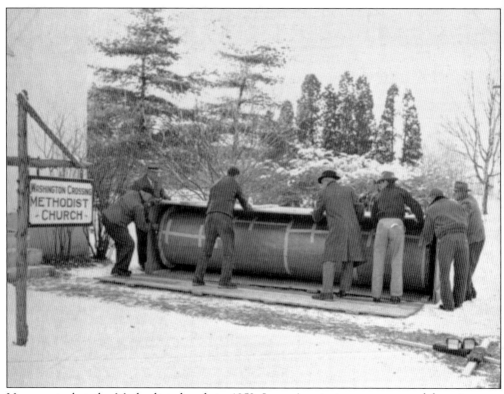

Upon arrival at the Methodist church in 1952, Leutze's painting was removed from its crate in the snow. For its shipment, the painting was wound again around a tremendous drum with painstaking care by the Metropolitan's curatorial department. Church doors and half the pews were detached to fit the enormous canvas inside. The museum learned just the month before of the painting's temporary home after receiving a letter from church pastor Rev. Jesse Eaton that included a sketch of the wall where it would be hung. (MET.)

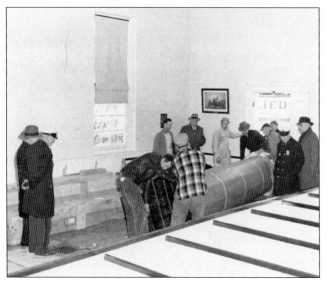

Under the supervision of the Metropolitan's Murray Pease, Emanuel Leutze's masterwork was laid face down on butcher paper on the floor of the Methodist church and slowly attached to a stretcher over two days as a special wooden base was built to support the 800 pounds. An unveiling ceremony was planned for Washington's birthday, February 22, 1952, and afterward, the painting could be viewed anytime except during church services. A 24-hour armed guard was stationed at the painting for its eventual seven-year stay. (MET.)

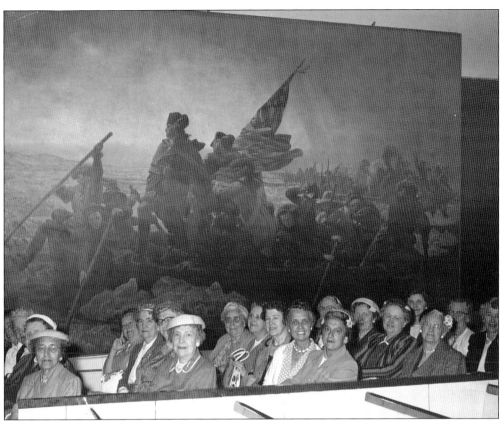

A gathering of church women poses for a picture around 1955 with Emanuel Leutze's painting of *Washington Crossing the Delaware* displayed in the sanctuary of the Washington Crossing Methodist Church. The church congregation began when Samuel Taylor, a skilled Quaker carpenter, experienced a spiritual conversation at a Methodist camp meeting and resolved to build a Methodist church in Taylorsville, today's Washington Crossing. For several years before the church was constructed in 1855, the Methodists in the area worshipped in the Betts Schoolhouse on Woodhill Road. (PHMC.)

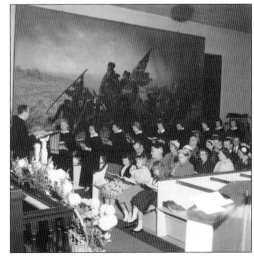

The Reverend Thomas B. Everist of the Washington Crossing Methodist Church, seen standing at the lectern at far left, leads his congregation in singing during the church's 100th-anniversary celebration in 1955. The choir appears to stand only inches away from Emanuel Leutze's painting of *Washington Crossing the Delaware*. (WCUMC.)

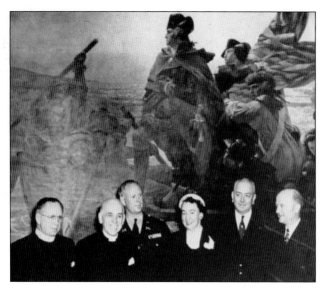

More than a thousand people attended the unveiling ceremony to celebrate the arrival of the Leutze painting at the Methodist church on the 220th anniversary of George Washington's birth in 1952. Seen from left to right are Rev. Jesse Eaton, Dr. Charles Kitto, Maj. Walter Carroll Jr., Ann Hawkes Hutton, state senator Edward Watson, and Congressman Karl King. The painting remained at the church until August 1959, when it was transferred to the new auditorium at the Washington Crossing Memorial Building. (AC.)

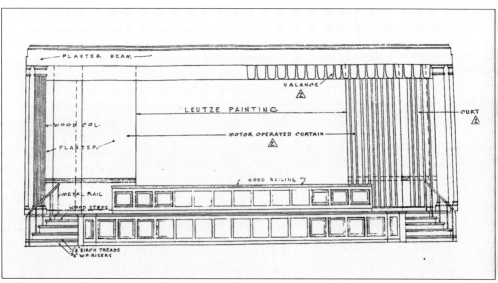

In the summer of 1959, Emanuel Leutze's *Washington Crossing the Delaware* was hung on the front wall of the auditorium of the new Washington Crossing Memorial Building. It was surrounded by maroon velvet curtains with another set that was opened and closed every half-hour for 16 showings per day. Hundreds of thousands of people came each year until 1969, when the Metropolitan denied another loan. But for the first time ever, it granted permission for a copy of one of its paintings to be made. (PHMC.)

Ann Hawkes Hutton is seen here admiring the beginnings of the full-scale copy of Leutze's *Washington Crossing the Delaware* by artist Robert Williams in 1969. To the delight of visitors and scores of schoolchildren daily, Williams painted in the memorial building's auditorium, allowing everyone to watch as he recreated Leutze's work stroke by stroke. Williams said of the crowds, "They help me relax and work quickly." Hawkes Hutton personally paid over $10,000 for the copy in honor of her late husband, John. (MET.)

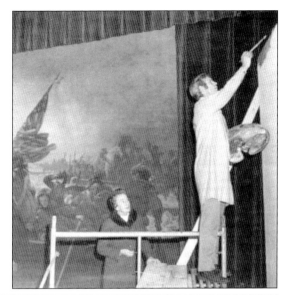

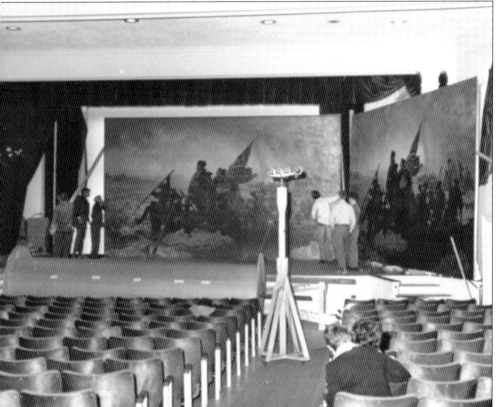

Robert Williams completed the copy of Leutze's masterpiece on Christmas day in 1969, the 193rd anniversary of the crossing. The original was rolled, yet again, around a giant drum to be returned to the Metropolitan in January 1970. A few critics of Williams contended that the copy was painted haphazardly, and he responded, "They don't know what they are talking about." The painting was so well executed that most visitors believed they were seeing the original. (MET.)

MODEL USED IN CARVING

Bedford, Indiana

American Revolution Bicentennial Celebration

CARVERS AT WORK ON STATUE

Indiana limestone can be found in many of the nation's capital buildings, such as the National Archives, the Washington Cathedral, and the Pentagon. As the United States was approaching its 200th birthday, chamber of commerce official Merle Edington in Bedford, Indiana, wanted to present the American people with a gift from the citizens of Bedford in celebration of the occasion. He envisioned depicting an important event from the American Revolution. Visiting various historic sites in Pennsylvania for inspiration, Edington, along with stone carver Frank A. Arena Jr., entered Washington Crossing Historic Park on a cold December afternoon in 1973. They met with Ann Hawkes Hutton, founder and chair of the Washington Crossing Foundation. She also served on the American Revolution Bicentennial Administration, an appointment given to her by Pres. Richard Nixon. From the meeting came the idea to create a life-sized three-dimensional statuary of Emanuel Leutze's painting of *Washington Crossing the Delaware* to be placed on a spot overlooking the Delaware River and created from Indiana limestone. (WCF.)

Architectural monument sculptor Frank A. Arena Jr., seen here, begins to recreate Leutze's canvas after his visit to the crossing site in 1973. He carefully studied Leutze's painting to become even more familiar with the subject. He spent hours trying to figure a way to create a lifelike three-dimensional portrayal of a painting that only showed the front and sides of the figures. In the beginning, Arena worked alone, but he soon acquired the assistance of fellow carver James E. Saladee. (WCF.)

Pictured is the three-dimensional model created by Frank Arena of Emanuel Leutze's familiar painting *Washington Crossing the Delaware*. An old service station became Arena's new studio. A hydraulic auto lift that remained served as a pedestal upon which the 1,000-pound clay, wood, and copper-tubing model was constructed. Using his own creative talents, Arena was able to take Leutze's two-dimensional painting and supply details to the backside of the sculpture. He completed the model in less than six months. (WCF.)

In August 1974, the selection of stone type for the statuary was chosen. The limestone used in the creation of the statuary was cut from a vein of prime limestone known as "Carrara." Eighty tons of stone lugged into cube-shaped blocks was extracted from the Shawnee Quarry near South Union, Indiana. The quarry, operated by the David Elliott Stone Company, provided the stone as a gift to the Bedford bicentennial project. (WCF.)

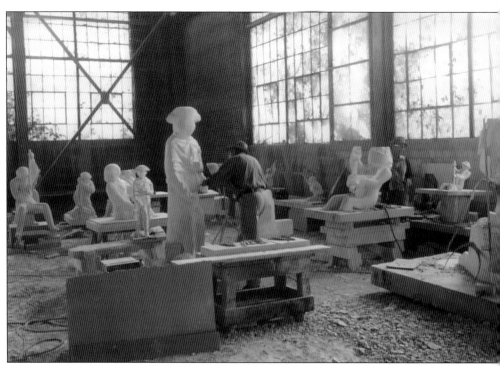

Many of the figures start to take shape in this June 9, 1975, photograph. Larry Vincent Grubbs wa the primary stone cutter on the project, along with a handful of other stone cutters, employees o the Woolery Stone Company, who worked to bring out the human figures and the boat from the slabs. Each of the 12 figures, along with the boat, was carved separately. The individual human figures demanded the most of the sculptors' craftsmanship and artistry. (WCF.)

With chisel in hand, James Saladee, seen here, applies the finishing touches to Washington's collar. Both he and Arena worked diligently on each figure, which became in its own right a piece of artwork. Each figure was created with absolute traditionalism to the painting. When all 26 separate pieces were placed together in the 17-foot-long hull of the boat for the first time, Emanuel Leutze's painting came to life. (WCF.)

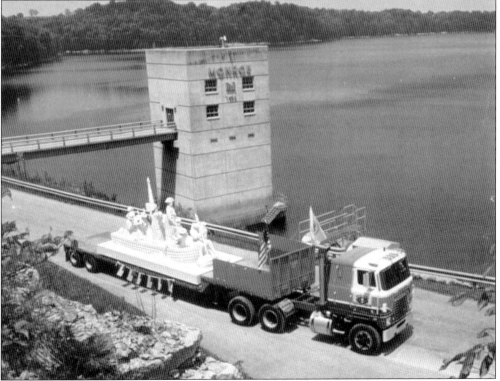

In April 1976, Bedford's gift to the nation was ready for delivery. Moon Freight Lines Inc. voluntarily transported the statuary on the back of a flatbed COF-4070B tractor trailer painted red, white, and blue, with lots of gleaming chrome. The statuary made several ceremonial and festival appearances throughout Indiana before making the 850-mile journey to Pennsylvania. The statuary made stops in various communities through Ohio, West Virginia, and Pennsylvania before arriving in Washington Crossing on June 14. (WCF.)

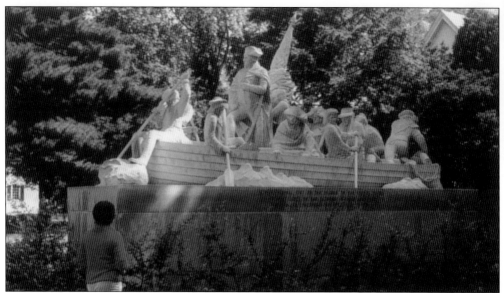

The 30-ton statuary arrived on June 14, 1976, and was installed at its present location near the Washington Crossing Inn. The monument measures 21 feet long, 8 feet wide, and more than 15 feet tall from the bottom of the base to the top of its flag. One laborer who worked to epoxy the 12 individual statues to the boat claimed he hid a miniature flag, a bicentennial half dollar, and the names of the sculptors, along with names of his wife and children, in the glue that fastened the final statue to the boat. (WCF.)

The dedication program of the Washington Crossing Statuary was held on July 5, 1976. It was reported that nearly 600 people were in attendance, including state officials from both Pennsylvania and Indiana. "It will stand," said Rev. Robert Anderson, rector of St. John's Episcopal Church in Bedford, who led the program, "a perpetual witness to the blessings of this nation and for the men who lived and died for causes beyond their own." (WCF.)

Five

THE MANY FACETS OF THE DELAWARE RIVER

"The origins of the current Christmas Crossing re-enactments were born of a series of events over a number of years," writes author Peter Osborne in his authoritative work *No Spot in This Far Land Is More Immortalized: A History of Pennsylvania's Washington Crossing Historic Park*. St. John "Sinjun" Terrell, seen here around 1970 resting his boot on the monument with fellow re-enactors, began recreating the crossing in 1953. The event has become an annual tradition, drawing upward of 10,000 spectators to Washington Crossing Historic Park each Christmas day. (WCF.)

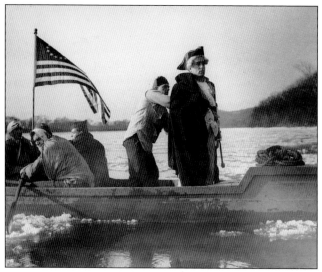

On January 23, 1947, some 40 pledges of Phi Sigma Nu fraternity from Rider College (now Rider University) staged a re-enactment of Washington's crossing of the Delaware. The nonhazing event was the idea of two Rider students—Frank Ewart and Donald Reynolds—as an entertaining way to draw attention to the fraternity. George Chafey (standing) portrayed General Washington, Joseph Brelsford was General Sullivan, and William Clark was General Greene; Theodore Genola is dressed in a buckskin uniform. (RUA.)

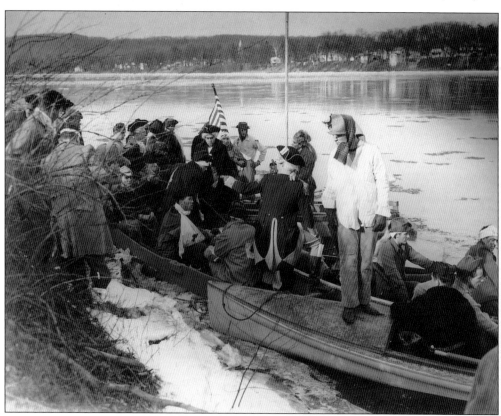

Strong currents and ice made for a few harrowing moments during the crossing, but the Rider fraternity brothers navigated across the Delaware in 12 minutes in four rickety rowboats. Dean J. Goodner Gill of Rider College cut short classes for the day to permit students to witness the event. As the re-enactors approached the Jersey shoreline, they were greeted by rival Delta Sigma Pi fraternity members, who pelted them with oranges, tomatoes, and firecrackers. Phi Sigma returned fire with snowballs. (RUA.)

In keeping with the historical account of the Christmas night crossing, George Chafey portraying Washington led his band of "Colonial" fraternity brothers up Continental Lane to Bear Tavern. Chafey, who was fearful of horses and nursing a bad cold, chose to ride a bicycle, as immortalized in this photograph. Arnie Ropeik, who worked for the *Rider News*, a college publication, convinced *Life* magazine to chronicle the event. The story appeared as a four-page photo spread in the February 17, 1947, issue of the magazine. (RUA.)

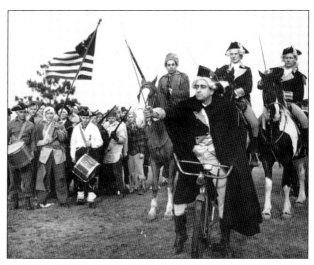

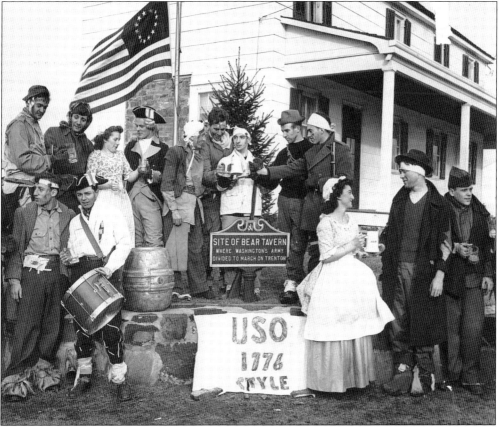

After marching through the WCSP on Continental Lane, the re-enactors took respite at a "USO" canteen operated by Barbara Silcox and Mary Jane Costa at the intersection of Bear Tavern Road. With ketchup-soaked bandages and muskets ready, the band continued its nine-mile trip to the Battle Monument in Trenton for a mock battle against the Hessians. The weapons of choice turned out to be pillows and fruit. Only one casualty was reported: a woman was struck in the head with a tomato as she was leaning out the window to witness the skirmish. (RUA.)

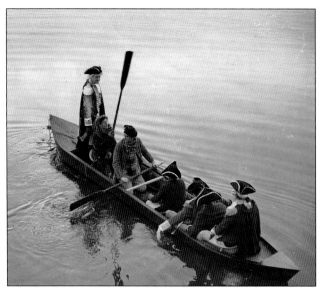

Actor St. John "Sinjun" Terrell (standing) began the first modern re-enactments of the crossing of the Delaware in 1953. With six friends in rented costumes in a half-scale Durham boat built by Lambertville carpenter Elmer Case, he staged Emanuel Leutze's iconic painting. Third from the left is New Hope photographer George Bailey; other participants included Thomas Marshall as Gen. Hugh Mercer, Elmer Case, Jesse Livermore as Nathanael Greene, Robert Walter as Lt. James Monroe, and Lowell Birrell as Col. Henry Knox. (TFPL.)

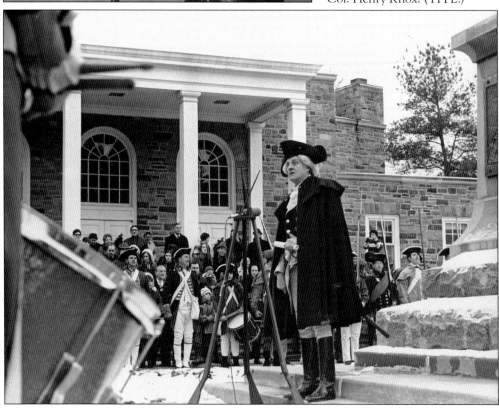

Standing at the WCHP visitor center around the 1960s, St. John Terrell, as George Washington, addresses a crowd. Known as a master showman, Terrell, a founding producer for the Bucks County Playhouse and creator of the Lambertville Music Circus, casually mentioned the idea of a re-enactment in 1953 during a lecture. It made headlines in a local paper, so Terrell had to follow through. Deemed "tawdry" and "shameless" by some park officials, the event was so popular that Terrell continued to play Washington for the next 24 years. (PHMC.)

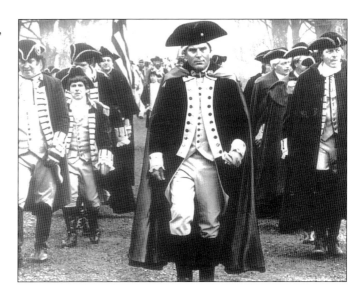

John "Jack" Kelly Jr. (center), brother to Princess Grace Kelly of Monaco and former Olympic rower, was a nine-year crew member who rowed St. John Terrell across the Delaware before assuming the role of George Washington for the first time in 1978. With a striking resemblance to Washington, he would often sign autographs "Jack Kelly–George Washington." Kelly would make seven crossings as Washington until his untimely death in 1985. (WCF.)

Between 1997 and 2012, several contests were held for the coveted role of George Washington for the annual Christmas re-enactment of the crossing of the Delaware. Candidates were judged on their knowledge of the Revolutionary War, their uniforms, and their ability to recite passages from Thomas Paine's *American Crisis*. Pictured at the WCHP visitor center around 2007 are contestants, from left to right, William Agress, Sam Davis, Robert Gerenger, John Gozieba, and Patrick Jorden. (RR.)

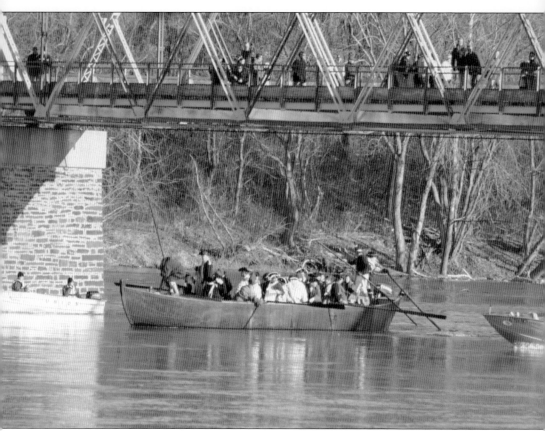

"Overpowering current diminishes Washington's 'attack' on Trenton," began the article in the December 26, 2007, edition of the *Trentonian* of the rescue of one of Washington's boats during the 55th annual Christmas day crossing re-enactment. A strong river current caused the first boat that ventured across the Delaware to drift dangerously under the Washington Crossing Bridge. The New Jersey State Police Marine Division, which patrols the event, quickly rescued the drifting vessel and safely towed the 25 re-enactors aboard back to the Pennsylvania shoreline. "We're kind of at the mercy of the river," stated Hillary Krueger, director of the WCHP, which hosts the re-enactment. The rowing portion of the event was then canceled, but Washington's troops, determined to complete their mission, pressed onward by marching across the bridge into New Jersey. Conditions on the river vary from year to year, and the ability to cross the Delaware safely for each event is taken seriously, at times causing the rowing portion to be postponed. In December 2020, the WCHP, out of concern for public safety, canceled the Christmas day program due to the COVID-19 pandemic. (RS.)

Ronald Rinaldi II (left), as a continental officer, is pictured here with his father, Ronald Rinaldi Sr., as a militiaman, during the WCHP's Christmas day re-enactment in 1993. Rinaldi developed a passion for living history, and like many re-enactors, he continually studied the era's history, soldiers' uniforms, and accouterments, and his father followed his lead. In 2007 and 2008, he won the contest to portray George Washington, and he has never missed a Christmas crossing of the Delaware in almost 50 years. (RR.)

Because re-enactors frequently travel for events and living history programs, it often becomes a family affair as generations become involved and take on historical roles. Pictured here on Christmas day 2018 are, from left to right, Ronald Rinaldi III (who began re-enacting as a drummer boy at age seven and wore his father's old hand-sewn uniform), James Rinaldi as an enlisted man, Ronald Rinaldi II as General Greene, and Nicole Rinaldi as a soldier's wife. (RR.)

On May 20, 1931, troops of the First Division, US Army, encamped at Washington Crossing, Pennsylvania, started their second day of military training exercises by crossing the Delaware River. Soldiers from Company H, 16th Infantry, and Company B, 18th Infantry, stationed at Camp Dix (renamed Fort Dix) erected a footbridge to Taylor's Island, while most of the men, equipped with the most modern of warfare tools, were ferried across the river on rafts constructed from aluminum and duralumin pontoon boats. (RGM.)

During the 1920s and 1930s, regiments engaged in normal peacetime training routines; platoon training was held in the winter and spring. Two public demonstrations were held presenting the construction of a new experimental pontoon bridge system to carry troops and animals across the Delaware River, which drew crowds of spectators. The maneuvers were filmed, and portions were shown at the RKO Lincoln Theater on North Warren Street in Trenton. (RGM.)

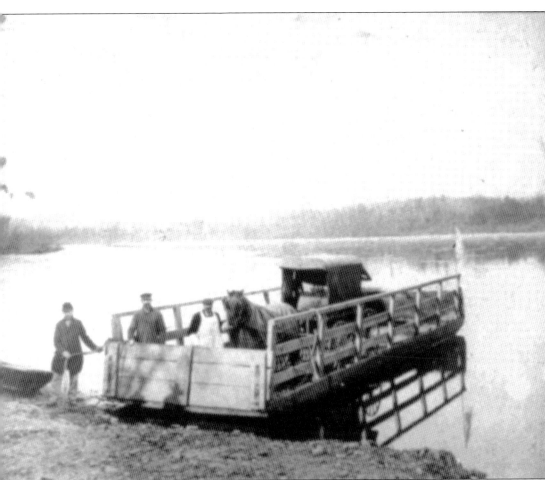

Ferry service on the Delaware River linking Mercer County, New Jersey, and Bucks County, Pennsylvania, dates back as early as 1675. Two ferries operated in the same vicinity on the Delaware at the time of the 1776 Christmas campaign: McConkey's ferry in Pennsylvania and the Johnson ferry in New Jersey. Early ferries on the Delaware were named for the parties who owned the land. The ferries operated on a system of pulleys and ropes that were strung across the river; ferrymen using poles pulled and pushed the flat-bottomed scows across the current. On Christmas night, the ferries that were used to transport the horses, ammunition wagons, and heavy artillery of Washington's army measured up to 50 feet long and 12 feet wide. By the 1800s, bridges began to replace ferries at narrow crossing points, such as the crossing at Trenton and Morrisville, Pennsylvania. The last ferry to cross the Delaware at Washington Crossing was in 1835, after the construction of the covered bridge. It was brought back into service temporarily in 1903 after floodwaters destroyed the bridge. This image is of that ferry. Noticeable in the image is the tip to Taylor's Island on the left. (RGM.)

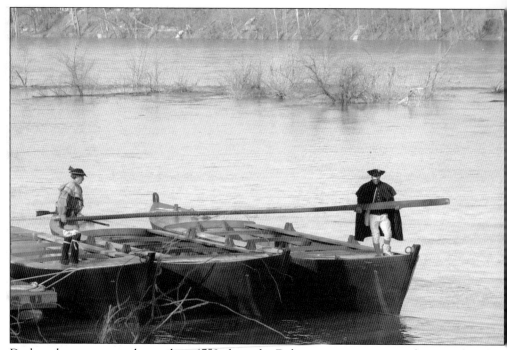

Durham boats were used as early as 1758 along the Delaware to transport products produced by the Durham mills and forges located in upper Bucks County. The flat-bottom, double-ended design allowed the boat to move swiftly and carry 15–18 tons downstream and 2 tons upstream. Measuring 60 feet long, 6 feet wide, and 3 feet deep, they were manned by a crew of three to six men. After the construction of canals on both sides of the Delaware, the use of these boats diminished. (RS.)

In 1965, the first full-scale replica Durham boat, seen here under construction, was used by re-enactors to cross the Delaware. No original Durham boats existed to be copied, so construction plans were researched by Ann Hawkes Hutton and Ivy Jackson Banks, a teacher and librarian at the WCHP. Built by the Johnson Brothers Boat Works of Point Pleasant, New Jersey, when it launched, it was thought to have been the first Durham boat seen on the river in over 100 years. (PHMC.)

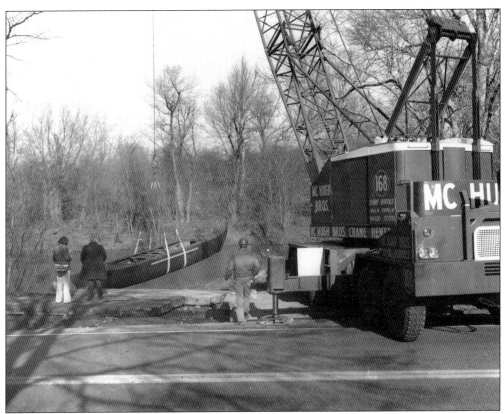

For many years, using a large crane, McHugh Brothers Heavy Hauling Company of Penndel, Pennsylvania, seen here around 1973, donated its services to raise the Durham boats in and out of the Delaware River from storage at the WCHP. By the time of the nation's bicentennial, four reproduction Durham boats, each costing about $50,000, were added to the crossing program through gifts from private individuals and organizations to enhance the authenticity of the event. (PHMC.)

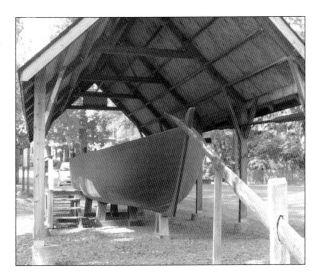

A replica of a Durham boat sits on display near the Durham Post Office in Durham, Pennsylvania. The boat, once part of the collections of the Washington Crossing Foundation, was used for many years during the annual Christmas day crossing re-enactments on the Delaware. Now part of the Durham Historical Society's collection, it sits under a pavilion located in the public green that can be viewed by anyone. The replica now displayed in Durham was used for a re-enactment of Washington's crossing in Pres. George H.W. Bush's inaugural parade in 1989. (AC.)

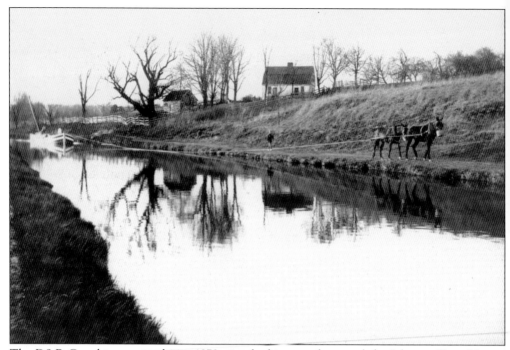

The D&R Canal is seen in this c. 1870 view looking north toward the Johnson Ferry House. Work began on the 22-mile feeder canal in 1830 and was completed in 1834 at an estimated cost of $2.83 million. The feeder, which supplies water to the main canal, begins two miles north of Stockton and travels southward along the Delaware River to Trenton, where it feeds into the main D&R Canal and runs 44 miles north to New Brunswick. Between the 1860s and 1870s, the canal's greatest use was to transport coal from Pennsylvania to New York City. (WCPAA.)

The Delaware Canal, also called the Delaware Division Canal (DDC), was part of a larger system that spurred off from the Erie Canal in New York. Construction on the DDC, which runs from Bristol to Easton, began in 1831 and was completed in 1832. Constructed entirely with hand tools using primarily imported labor from Ireland, the 60-mile-long canal connects with the Lehigh Canal, which opened in 1829. Its main purpose was to transport anthracite coal from the northeastern Pennsylvania coal regions to the cities on the Eastern Seaboard. (AC.)

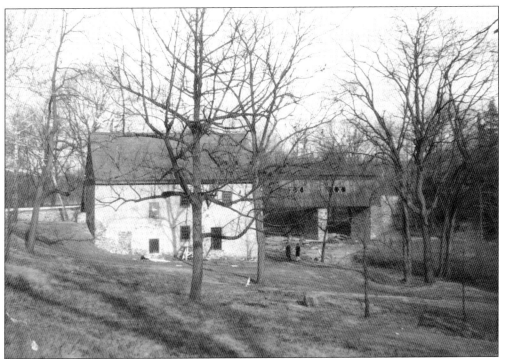

The Neely Grist Mill and covered bridge over the Pidcock Creek on Route 32 are seen in this c. 1920s image. During the 19th century, Bucks County had more than 50 covered bridges linking communities across the county so they could trade goods produced by local mills. These were built using a series of overlapping triangles with no arches or upright beams and could support a bridge 200 feet long. The cover protects the wooden timbers supporting the bridge from decay. Twelve of these bridges remain in Bucks County. (PHMC.)

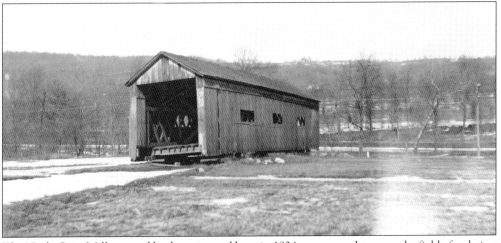

The Neely Grist Mill covered bridge, pictured here in 1934, was moved to a nearby field after being replaced by a new stone arch bridge. The *Trenton Evening Times* reported in 1936 that the old bridge was to "be demolished instead of being preserved as a relic of old time bridge construction." Supporters urged park commissioners to preserve the bridge. Park superintendent Dr. John A. Flood felt the cost was more than the bridge was worth. In April 1937, the bridge was dismantled, and usable materials were kept for park use. (BCHS.)

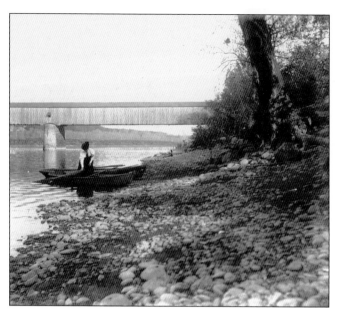

The Washington Crossing covered bridge, pictured here around 1895, was built in 1841. It replaced a previous bridge constructed in 1834 by the Taylorsville-Delaware Bridge Company that was swept away by the flood of January 8, 1841. On October 10, 1903, floodwaters destroyed the bridge seen here. The *Central News*, in Perkasie, Pennsylvania, on October 15, 1903, reported, "Along the entire banks of the Delaware in Bucks county bridges went down like ten pins, and Pennsylvania is partially divorced from New Jersey." (BCHS.)

Seen here are the remains of the Washington Crossing covered bridge after devastating floodwaters washed the bridge away in October 1903. The flood would be forever remembered as the great "Pumpkin Flood" for the hundreds of pumpkins dislodged from their fields by the raging water that littered the riverbanks in the flood's wake. Fourteen inches of rain had fallen in four days. Nine bridges in all were washed away, including the railroad span at Raven Rock in Hunterdon County. (RGM.)

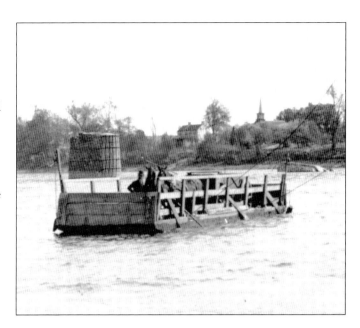

"At Washington Crossing where the bridge was swept away, a ferry will be established by the bridge company as soon as the water receeds. This ferry will be operated until a bridge can be erected," reported the *Daily State Gazette* on October 13, 1903. The Taylorsville-Delaware Bridge Company strung a new cable across the river for $175, built a flatboat for $165, and sold the wreckage of the old bridge for $100. In this rare image, a stone pier from the old bridge is noticeable behind the ferry. (RGM.)

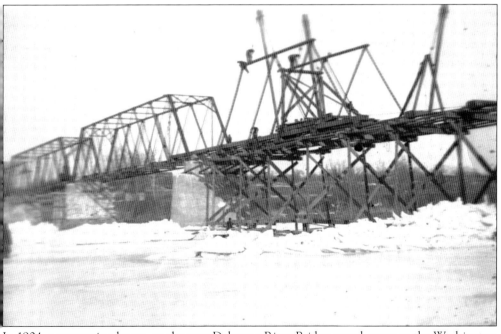

In 1904, construction began on the new Delaware River Bridge, now known as the Washington Crossing Bridge. Constructed for $26,775.25, the bridge is a six-span riveted-steel double Warren truss type of engineering, employing a weight-saving design based upon equilateral triangles. It spans 877 feet across the river and rests upon the original 1834 masonry piers. The open steel grid deck provides a clear roadway width of 15 feet between steel channel rub-rails. The Washington Crossing Bridge is also one of only two major bridges in the United States where the bridge crosses between two towns of the same name in different states. (RGM.)

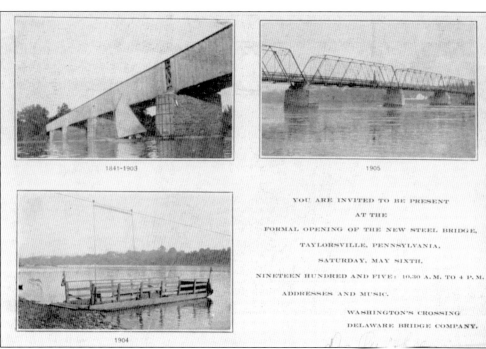

The "Formal Opening of the New Steel Bridge" connecting Taylorsville, Pennsylvania, and Washington's Crossing, New Jersey, was held on Saturday, May 6, 1905. An article in the *Intelligencer* newspaper reads in part, "The little village of Taylorsville was put in gala attire for the occasion, the bridge was gay with flags and streamers and the residences were draped with bunting." A brass band from Philadelphia provided music, while speeches were made by elected officials from both states. After the ceremony, the bridge was opened to the public. (BCHS.)

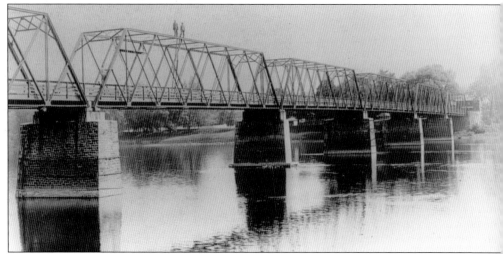

In 1919, Pennsylvania and New Jersey set up a joint bridge commission to regulate the Delaware River bridges. The commission began the process of buying the bridges and converting them into toll-free steel structures. On April 25, 1922, the commission purchased the Delaware Bridge from the Taylorsville-Delaware Bridge Company for $40,000. The bridge soon underwent considerable upgrades in the mid-1920s, which included a pedestrian walkway on the south side. The bridge is currently owned and operated by the Delaware River Joint Toll Bridge Commission. (RGM.)

In May 1942, three days of heavy rainfall caused serious flooding in the Delaware and Lackawanna River Basin. A report published in August 1942 by the Commonwealth of Pennsylvania Department of Forests and Waters estimated losses attributed to the floods at $15 million. Thirty-three lost their lives, 35 bridges were washed out, and 22 state highway routes were damaged. Seen here are floodwaters from the Delaware River surrounding the Bucks County Historical Society monument. (BCHS.)

The flood of 1955 devastated both parks and their neighboring communities. Back-to-back hurricanes, Connie and Diane, slammed the Eastern Seaboard and turned the Delaware into a raging nightmare, destroying lives, homes, and businesses. As the river crested on August 19, "River Jim" Abbott, a Titusville marina owner, motored his boat through the WCSP to nail the record high-water mark to a tree. The sign became a popular souvenir item that Abbott would replace many times. (WCPAA.)

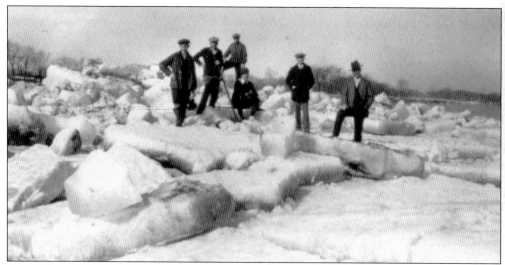

From left to right, J. Bigley, Walt Sharp, Charles Mathew, Malcolm Joiner, John Bowlby, and Harris Knowles are pictured standing on ice chunks that have gathered on the Delaware River near the Washington Crossing Bridge around 1923. Several external factors go into the freezing of the Delaware River: temperatures well below zero, a number days of consistent subfreezing temperatures, the salinity level of the river, and river flow. Less salt in the water means quicker freezing, and slower water flow increases freezing. All these factors are conditions for ice on the river. (RGM.)

From left to right, David Scott, Elwood Reynolds, Richard Heckman, and Thomas Ivey stand upon a frozen Delaware River near Morrisville, Pennsylvania, on February 11, 1945. Weather records for the winter of 1944–1945 show temperatures averaged 3.5 degrees Fahrenheit below average in December and 6.2 degrees Fahrenheit below average in January, allowing the Delaware to freeze. The river was frozen from December 26, 2017, to January 8, 2018, when temperatures never reached above 32 degrees Fahrenheit. Those subfreezing temperatures tied with 1940 and 1979 as the second-longest cold spell recorded in the Delaware Valley. (BCHS.)

In the 1920s, swimming in the Delaware River became a popular respite from the summer heat. The WCHP opened three bathing beaches: one south of the Mahlon Taylor House, one in front of the McConkey Ferry Inn (as seen here around 1925, taken from the Washington Crossing Bridge), and another on Taylor's Island. Floatation platforms were constructed and placed in the river for swimmers, along with a wharf for canoes and motorboats. (TFPL.)

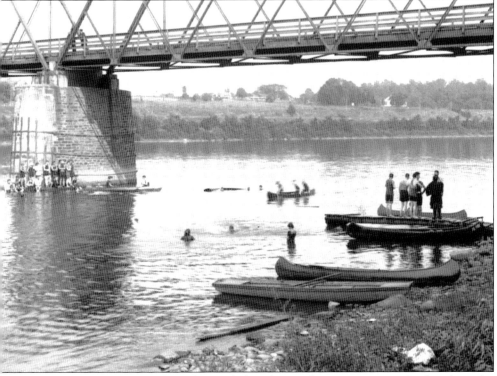

Bathers enjoy a cool swim in the Delaware below the Washington Crossing Bridge along the Pennsylvania shoreline around 1929. Since the New Jersey park provided no formal beach or bathhouse, many residents crossed the river to enjoy the swimming facilities at the Pennsylvania park. These out-of-state visitors soon were given the reputation as being undesirable and annoying. Due to the complaints of bathers changing in their cars, in 1928, a new bathhouse was constructed in the Pennsylvania park. A dress code was implemented for bathers strolling park grounds. (RGM.)

101

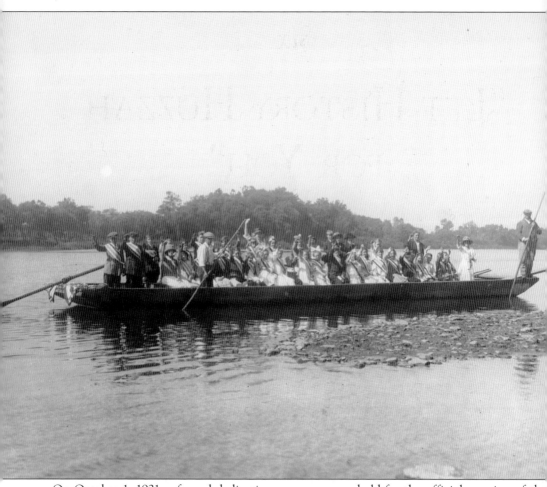

On October 1, 1921, a formal dedication ceremony was held for the official opening of the Washington Crossing Historic Park. As part of the festivities, 50 schoolchildren were treated to a boat ride in what was described as a replica of a Durham boat across the river. This picture is believed to have been taken that day. The idea of children enjoying a boat ride across the Delaware was not new. In a c. 1922 letter by park commissioner Samuel Eastburn, he proposed "That the Commission here will have built a boat a replica of the Delaware boats (I have the dimensions & pictures). That it should be launched at the place of embarkation and 'poled by Bucks County boater' (these could be employees of the Park) across the landing place on NJ side. There should be a sign at start. Say 'Let your children cross [experience] of Washington's Crossing that they may always feel an intimate fact in that heroic event.' Let the charge be 50¢ which should include a 6x8 picture of them and their friends crossing." (PHMC.)

Six
"Let History Huzzah for You"

The Fourth of July is the most celebrated patriotic day in the United States, as seen in this 1920s image that displays a float depicting Emanuel Leutze's painting of *Washington Crossing the Delaware*. John Adams, in a letter to his wife, Abigail, writes, "I am apt to believe that it will be celebrated, by succeeding Generations, as the great anniversary Festival . . . with Pomp and Parade, with Shews [sic], Games, Sports, Bells, Bonfires and Illuminations from one End of this Continent to the other." (AC.)

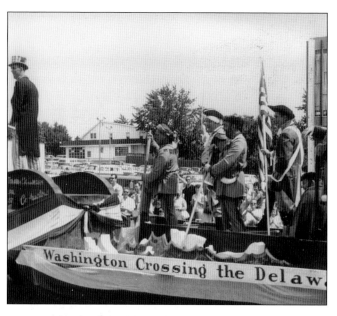

Celebrating Independence Day around 1976, this float depicting Washington crossing the Delaware was towed by Tinari & McNamara Contractors of Southampton, Pennsylvania. In 1861, Abraham Lincoln addressed the New Jersey Senate in Trenton and remarked, "I remember that in all the accounts then given of the battle fields and struggles for liberties of the country, none fixed themselves upon my imagination to deeply as the struggle here, at Trenton, New Jersey. The crossing of the river . . . all fixed themselves on my mind more than any single revolutionary event." (WCF.)

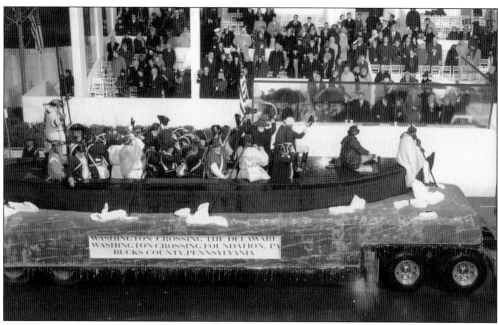

The Washington Crossing Foundation float depicting Washington crossing the Delaware passes by the reviewing stand during the inaugural parade for Pres. George Herbert Walker Bush on January 20, 1989, in Washington, DC. The tradition of inaugural parades on Pennsylvania Avenue dates back to Thomas Jefferson's second inauguration in 1805, when workers from the Washington Navy Yard accompanied him to the White House with military music. Today's parades feature both military and civilian participants from all 50 states and the District of Columbia. (PHMC.)

Author and historian Ann Hawkes Hutton served on the Washington Crossing Park Commission from 1939 to 1997. Her leadership brought worldwide attention to the yearly Christmas day crossing re-enactments; the loan of Emanuel Leutze's painting of *Washington Crossing the Delaware* from the Metropolitan Museum of Art to the park; and the construction of the Washington Crossing Memorial Building, to mention just a few. She was also the founder and chair of the nonprofit Washington Crossing Foundation. Her contributions and legacy will never be forgotten. (WCF.)

Dirk Van Dommelen, a native of the Netherlands, served as the superintendent of Washington Crossing State Park from 1958 to 1976. During his tenure, he was instrumental in helping to establish the Washington Crossing Association of New Jersey and helping to provide strong cultural and historical programs at the park that included the creation of the Open Air Theatre, nature center, flag museum, Nelson House, and Visitors Center Museum. To date, he has served the longest term as WCSP superintendent. (WCPAA.)

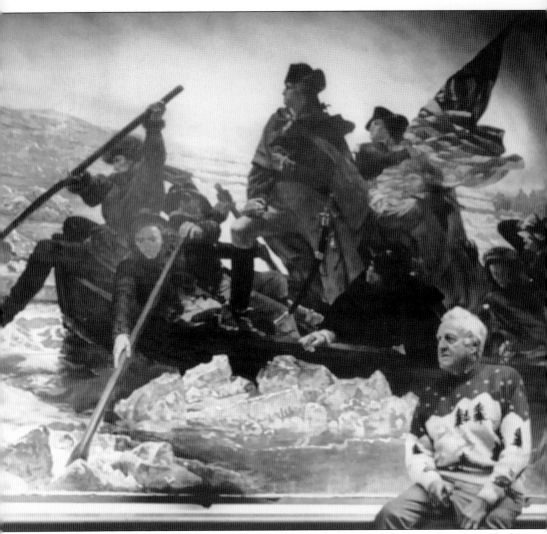

St. John Terrell is pictured here around 1990 with the replica of Emanuel Leutze's *Washington Crossing the Delaware* at the WCHP. Always flamboyant in his portrayal of George Washington during his 25-year run at the annual crossing re-enactment, he understood the draw of living history to bring people to the parks. Park commissioners, including Ann Hawkes Hutton, initially opposed the re-enactments, but she soon became a staunch ally, supporting the continuation with an aim of authenticity. They watched attendance grow every year. As Terrell ended his reign as General Washington, he remarked in an interview in 1977 in the *Philadelphia Inquirer*, "If I haven't made my point—and I'm not sure what my point might be—in 25 years, its hopeless." Terrell was recognized for his endeavors in the arts and history, appointed by Pres. John F. Kennedy as the chairman of the New Jersey Tercentenary Celebration Commission in 1963; he was also a charter member of the New Jersey State Council on the Arts and a trustee of the American Folk Life Center. (RR.)

William W. Farkas, seen with the 1895 Bucks County Historical Society monument at Washington Crossing Historic Park, left this earth on March 23, 2020. After retiring from his career at US Steel Corporation, he developed a fondness for both Washington Crossing parks, hiking the many trails and having picnics with friends. Curious about the history and the formation of both parks, he commissioned the writing talents of Peter Osborne to write two comprehensive histories. In 2017, William was honored for providing the funding for a new roof on the Sullivan Grove Pavilion in the Washington Crossing State Park. Pictured below from left to right are Stan Saperstein, WCPA board member; Mark Texel, assistant director of the New Jersey State Park Service Division of Parks and Forestry; William Farkas; Neal Ferrari, WCSP superintendent; and Joseph Carney, WCPA president. Farkas bequeathed both Washington Crossing parks a substantial gift for their betterment. His financial contributions will be a lasting gift and legacy. (Above, POC; below, DD.)

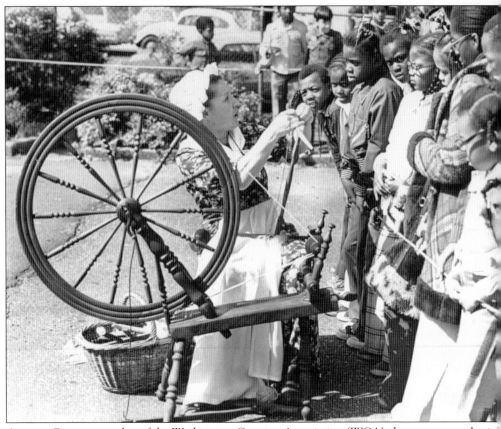

Annette Carter, a member of the Washington Crossing Association (WCA), demonstrates colonial spinning to schoolchildren in Trenton. Early plans for the development of the WCSP called for historical interpretation to incorporate more than the crossing story. The WCA, created in the 1960s, began a long relationship with the WCSP by helping to raise funds to support park-related projects and programs. Since 2013, the newly formed Washington Crossing Park Association (WCPA) has continued the mission to preserve, enhance, and advocate for the park and its history. (WCPAA.)

Friends of Washington Crossing Park (FWCP) staff member Tom Maddock reads a copy of the Declaration of Independence on July 4, 2013, at the McConkey Ferry Inn. The FWCP was created when budget cuts to the Pennsylvania Historical and Museum Commission in 2009 forced the closure of the WCHP and the cancelation of the Christmas day crossing re-enactment. Community and organizational support raised the necessary funds to hold the event that year. Today, the FWCP continues to support the operations of the park and its programs. (POC.)

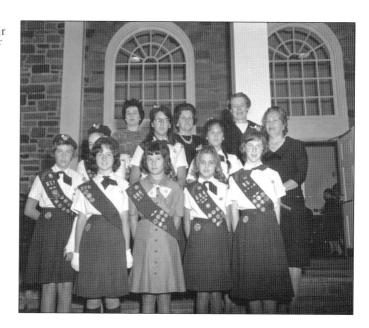

These Girl Scouts and their leaders pose on the steps of the Washington Crossing Memorial Building around 1965. Since the creation of both parks, the Boy and Girl Scouts have utilized them for their outdoor programs, which included the planting of memorial trees throughout the parks. In the 1930s, both Boy and Girl Scouts held large camporees at the base of Bowman's Hill. By the late 1950s, the parks saw nearly 4,000 Scouts annually. This number grew to more than 7,000 in the 1960s. (PHMC.)

In 1946, two thousand Boy Scouts participated in a camporee at the WCSP, making it the largest in the George Washington Council's history. Boy Scout Troop 1776 of Titusville, chartered September 1, 1935, is pictured during the camporee. They are, from left to right, (sitting) Olaf Harbourt, unidentified, Bob Wargo, Jack Schmidt, and unidentified; (kneeling) Alfred Wooden, Scudder Hallinger, John Stalb, Vinny Rockel, Cornelius Twomey, Wayne Hansen, Frank Wooden, and Jim Leming; (standing) unidentified, Ricky Eckhart, unidentified, Bill Rockel, Ken Colwell, Alysten Hart, unidentified, and Wayne Cadwalader. (RGM.)

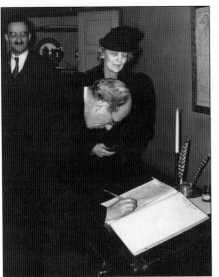

British ambassador to the United States and First Earl of Halifax Edward Frederick Lindley Wood and his wife, Lady Dorothy Evelyn Augusta Onslow, sign the guest registry during a visit to the Johnson Ferry House on December 15, 1944. Trenton City librarian and historian Howard L. Hughes (seen at left) led the tour, which also included a tour of the Old Barracks in Trenton and a visit to Princeton University, where Halifax presented a piece of stone from the House of Commons damaged by German bombings during World War II. (WCPAA.)

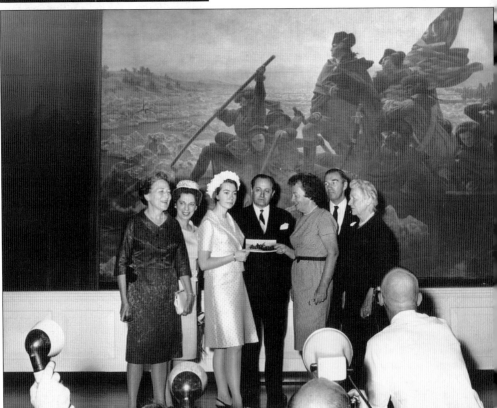

Princess Christina Louise Helena of Sweden (third from left) is presented a gift from Washington Crossing Park Commission chair Ann Hawkes Hutton during a visit to the park on June 11, 1965. The princess and her entourage were on a tour of the United States in part to commemorate the first Swedish settlers to arrive in southern New Jersey. The princess was also given a tour of the historic sites in Trenton and presented with a Lenox bowl by New Jersey governor Richard and Elizabeth Hughes. (PHMC.)

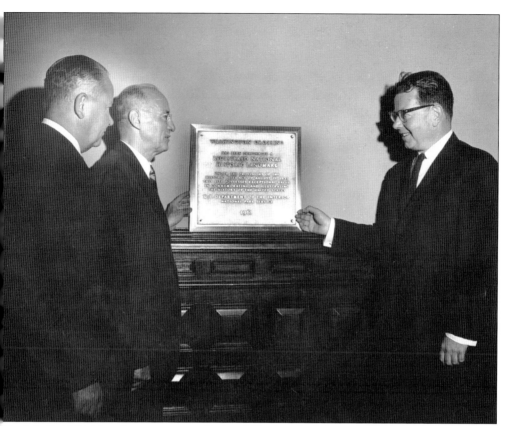

On July 9, 1962, New Jersey governor Richard Hughes (right) was presented with the plaque designating Washington Crossing as a national historic landmark. The US Department of Interior's National Park Service declared landmark status for Washington Crossing in 1961, which included both the New Jersey and Pennsylvania sides of the Delaware. A proposed joint ceremony between both states was discussed but never materialized. The plaque is currently mounted on the front of the Nelson House in the WCSP. (NJSA.)

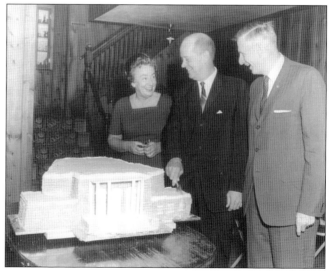

The fifth anniversary of the construction of the Washington Crossing Memorial Building was held on September 19, 1964. Speeches were given by local officials, and an honor guard of Bucks County Boy Scouts was present during the ceremonies. A cake in the shape of the building was created as part of the celebration. Pictured from left to right are Ann Hawkes Hutton, Mr. Bodley, and Dr. Maurice K. Goddard. (WCF.)

In the early portion of the 20th century, Titusville and Washington Crossing became pleasurable summer vacation spots for many Trentonians. Single-story bungalows began to appear in Titusville along newly created streets like Rivera and Trimmer Avenues and Grant Street. Seen here around 1900, this bungalow, named Don't Worry, was the home of the Zephaniah and Louisa West family. Several of these bungalows remain and have become year-round residences. (RGM.)

Alfred Panchall, G. Pemberton Hutchinson, Agnes Williams, and Mary DuBois enjoy an afternoon picnic at the mouth of the old Bowman's Hill copper mine on May 29, 1896. Founded by Dutch prospectors, the mine existed since the late 1600s near the present-day Parry Trail, now part of the Bowman's Hill Wildflower Preserve. It is unclear if this mine yielded much copper ore; it was rediscovered by John T. Neely in 1854. Full of snakes and bats, the 15-foot-diameter mine shaft was later blasted shut. (BCHS.)

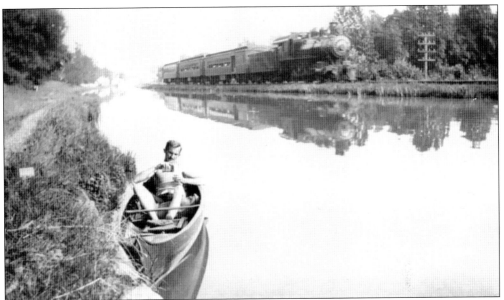

Pictured on July 22, 1915, Trenton resident Elwood Jordy relaxes in his canoe along the banks of the D&R Canal near the WCSP as a Bel-Del passenger train passes by. In the 1920s, pleasure boating on the canal became a popular activity, peaking in 1929. In 1937, the State of New Jersey took control of the main canal and feeder and converted them to a water supply system. In 1973, the D&R Canal was placed in the National Register of Historic Places, and it was officially designated the Delaware & Raritan State Park in 1974. (JW.)

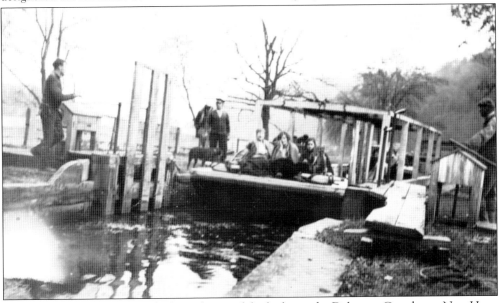

Friends enjoy a leisure boat ride through one of the locks on the Delaware Canal near New Hope in this c. 1925 image. Over its course of 60 miles, the Delaware Canal drops 165 feet through some 23 locks. Including its towpath and berm bank, the canal is approximately 60 feet wide and was originally five feet deep. In 1940, the Commonwealth of Pennsylvania acquired all 60 miles of the canal. It was designated a national historic landmark in 1978 and renamed Delaware Canal State Park in 1989. (BCHS.)

"Mercury Drops as Low Only Sixteen Times in Thirty Seven Years," read the headline that appeared in a January 6, 1904, article in the *Daily State Gazette* from Trenton. Temperatures in the region dropped 4 degrees below zero. The coldest temperature was recorded in River Vale in Bergen County at 34 degrees below zero, the coldest temperature ever recorded in the Garden State. Evidence of this cold blast is seen in this photograph of a horse-drawn sleigh on a frozen Delaware River with the Nelson House visible in the background. (RGM.)

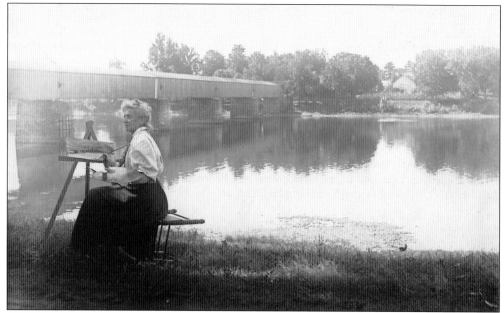

Around 1898, Hopewell Township resident and artist Mary M. Brower sits along the banks of the Delaware painting the Washington Crossing covered bridge in plein air. An illustration of one of her watercolors appears with an undated memoir she penned that recalls the changes in the old River Road from Washington's Crossing to Titusville. Titled "The Passing of an Old Road: Recalling Washington's March to Trenton," it was published in the *Sunday Advertiser*. (RGM.)

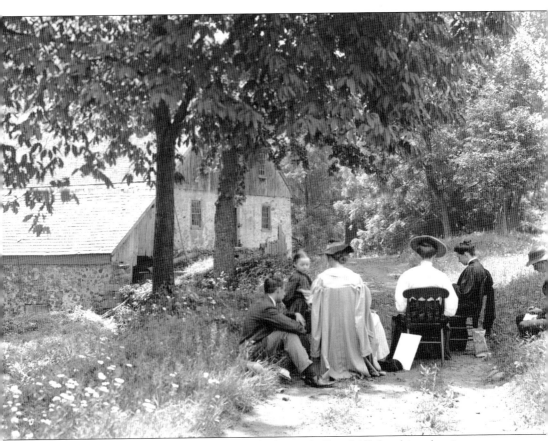

These artisans enjoy a leisurely afternoon alongside the Neely Grist Mill sketching the picturesque landscape near the present-day Bowman's Hill Wildflower Preserve in 1899. Bucks County has been the home of artists since the 1700s, but with the arrival of landscape painters William Langson Lathrop and Edward Redfield, who settled near New Hope, Pennsylvania, at the turn of the 20th century, the area established itself as a haven for the visual arts. Artists traveled from Philadelphia and New York, eager to paint the pastoral scenery in the region, including the views that would later become part of Washington Crossing Historic Park. These painters, later referred to as Pennsylvania Impressionists, painted in plein air, or outdoors, and concentrated on local scenes with close attention to brushwork to capture color, light, and atmosphere. Today, the Michener Art Museum, located in Doylestown, Pennsylvania, is considered to hold one of the finest collections of Pennsylvania Impressionist art. (BCHS.)

This painting by Edward Hicks is one of two that hung at each entrance of the 1834 covered bridge that once spanned the Delaware River at Washington Crossing. Hicks, a Quaker minister and coach and sign painter from Bucks County, modeled this work after Thomas Sully's 1819 *The Passage of the Delaware*. The sign was rescued by Huston Thompson moments before the bridge collapsed in the violent floodwaters of 1841. Later found in a Taylorsville store attic, it was acquired by Henry Mercer (of the Mercer Museum) in 1897. The painting at the New Jersey entrance was rescued also and stored at the Nelson House, then a tavern. It was exhibited at the Macy Galleries in New York City in 1932 and fell into private hands. It resurfaced at auction in 1997 and then again at Christie's in 2003. It sold for $361,500! (BCHS.)

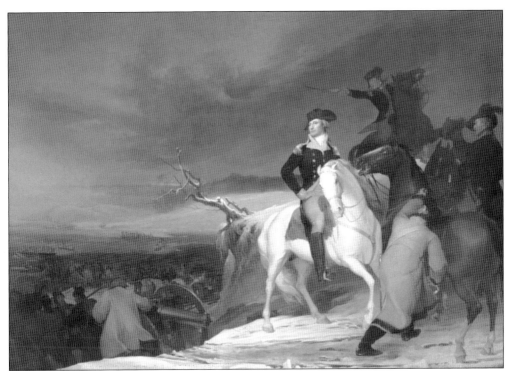

Thomas Sully's 1819 *The Passage of the Delaware* is one of his best-known paintings. Born in England, he settled in Philadelphia in 1808 and became a prolific portrait painter. This oil on canvas depicts Washington reviewing the artillery in 1776 shortly before he was to dismount his horse to join his army in crossing the Delaware. Sully purposely and dramatically highlights Washington, on a white horse, in the foreground, drawing attention to his posture of self assurance and control. The painting is exhibited in the Museum of Fine Arts in Boston. (MFA.)

William E. Pedrick completed his version of *Washington Crossing the Delaware* in 1893. A professionally trained artist and an amateur historian from New Jersey, he meticulously researched his subjects. He once delivered an address in 1923 to the Trenton Historical Society criticizing the inaccuracies in Emanuel Leutze's masterpiece, including that the ice was floating upriver. Pedrick's painting was given to the Trenton Free Public Library by his wife after his death in 1927, and it remains there today. (TFPL.)

117

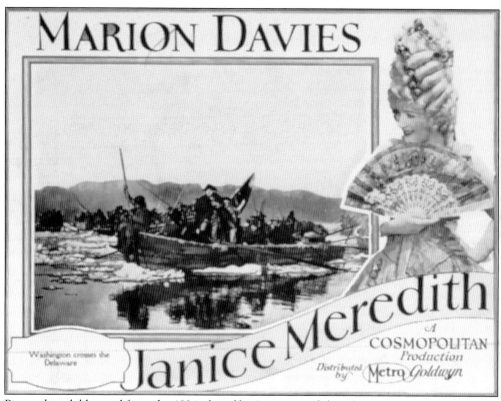

Pictured is a lobby card from the 1924 silent film *Janice Meredith*. Released by William Randolph Hearst's production company, Cosmopolitan, it was based on the 1899 best-selling romantic drama by Paul Leicester Ford. The cast included screen star Marion Davies as the protagonist, Joseph Kilgour as George Washington, and W.C. Fields as a British sergeant. The film featured dramatic scenes of the 1776 Christmas crossing of the Delaware and the Battle of Trenton. Billed as the "most inspiring picture ever made," it was shown at Trenton's G.B. Ten Eyck's Orpheum Theatre—$1 evenings and 50¢ matinees. (AC.)

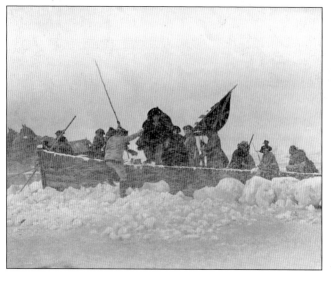

A mild winter forced the production of the movie *Janice Meredith* north to Plattsburg, New York, to ensure snow and ice for authenticity. The frozen Saranac River doubled for the Delaware in this recreation of the 1776 crossing from the movie. Over 7,000 people were employed to make the film, including 1,400 extras to man the boats. Many were injured in the ice flows, so Cosmopolitan offered $100 to each man who could stay in the icy waters for 5–10 minutes at a time during the shooting. (TFPL.)

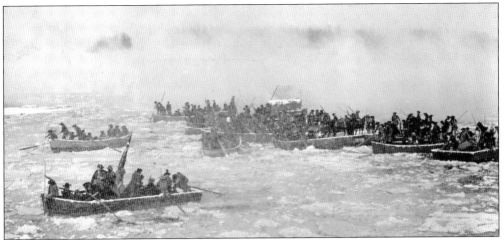

Director E. Mason Hopper described in a 1924 interview the complexity of filming the Delaware crossing scene in the film *Janice Meredith*. Under the three-foot-deep frozen Saranac River was soft anchor ice that would float to the surface each time an area was cleared. The ice was blasted with dynamite; 100 men worked three shifts to plow an 800-foot-long and 600-foot-wide channel to float the ice away over a dam. A half-dozen boats were smashed during the filming, and 12 cameras were used to shoot the scene. (TFPL.)

Production of *Janice Meredith* included the construction of a replica of the city of Trenton in Plattsburgh. Using old maps and engravings, two streets were recreated and over 50 structures built, with special attention paid to period architecture. Trenton's mayor, Frederick Donnelly, upon viewing his city in the film, was reported to "rub his eyes in amazement." When the snow melted around the set, 40,000 bags of confetti were purchased and a dozen men were employed hurling handfuls in front of airplane propellers to recreate the snowstorm for the battle scenes. (TFPL.)

In 1926, to celebrate the 150th anniversary of the signing of the Declaration of Independence and the crossing, writer Henry Paxton published this travel booklet entitled *Washington Crossing: Brief Itinerary of a Trip from Philadelphia to Washington Crossing and Other Points of Historic Interest in Bucks County, Pennsylvania*. The booklet is filled with pictures of historic houses and sites along a round-trip automobile excursion from Philadelphia to the crossing. Six thousand copies were printed. The booklet was given widespread acclaim from newspapers and historians. (TFPL.)

In 1928, New Jersey state forester Charles P. Wilber wrote this booklet on the history of the park. It was widely circulated and republished in 1931. The 18-page booklet, filled with images from within the park, covers the history of the Christmas crossing and highlights points of interest. Wilber's booklet is the first time "Continental Lane" was used to describe the old farm path that is believed to have been used by Washington's army to march on its way to the Battle of Trenton. (TFPL.)

The New Jersey state quarter was the third coin in the US Mint's 50 State Quarters Program. The series ran from 1999 through 2008 with the reverse side commemorating each state of the union. New Jersey's quarter depicted Emanuel Leutze's famed painting of *Washington Crossing the Delaware*. With this design, the New Jersey quarter was the first circulated coin to feature George Washington on both the obverse and reverse sides. (AC.)

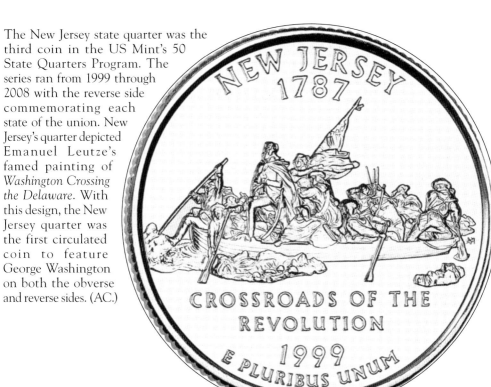

In 2021, the US Mint began issuing quarters with a reverse design depicting Gen. George Washington crossing an ice-choked Delaware River prior to the Battle of Trenton during the American Revolutionary War. This new design marked the end to the Mint's America the Beautiful Quarters Program, which featured reverses honoring national parks and other national sites. Created by Benjamin Sowards and sculpted by Michael Gaudioso, the image shows Washington commanding his troops through the overnight crossing. (AC.)

In 1932, the country celebrated the 200th birthday of one of the nation's founding fathers, George Washington. As part of the celebration, the Pennsylvania State Camp of the Patriotic Order Sons of America created this commemorative cachet that was postmarked at the Washington Crossing Post Office. The country, which was in the middle of the Great Depression, was in need of a celebration. The nation's enthusiasm toward Washington's birthday encouraged both the Pennsylvania and New Jersey parks to further develop and enhance their planning. One of the popular celebratory programs was the planting of trees. The Patriotic Order Sons of America planted 13 cedar trees near the George Washington memorial that stands in front of the WCHP's visitor center. These trees were brought from Ferry Farm, Washington's boyhood home in Virginia. On May 19, 1932, the WCSP dedicated the George Washington Memorial Arboretum by planting over 2,500 native trees and shrubs throughout eight acres of the park. (AC.)

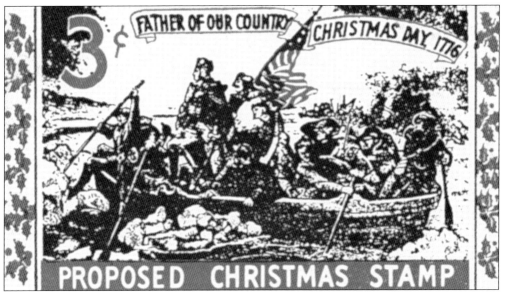

In 1950, Leopold Morris, the postmaster of Victoria, Texas, designed this stamp depicting Emanuel Leutze's painting of *Washington Crossing the Delaware*. Morris had hoped it would become the first US Christmas stamp. Concerned about the nonreligious theme of the design, the proposal was rejected by the US Post Office Department (USPOD). It was not until 1962 that the USPOD issued the first nonreligious Christmas stamp, picturing a Christmas wreath with candles. (AC.)

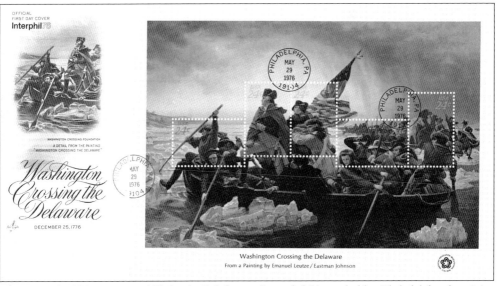

The Seventh US International Philatelic Exhibition, Interphil 76, was held in Philadelphia from May 29 through June 6, 1976. During the show, the US Postal Service issued four souvenir sheets with bicentennial themes: the Surrender of Cornwallis at Yorktown, the Declaration of Independence, Washington Crossing the Delaware, and the March to Valley Forge. Vincent Hoffman designed the sheets with perforations to permit five portions of each sheet to be removed and used as postage stamps. The sheets from the opening day were hand-stamped May 29, 1976. (AC.)

UNCLE'S POEM WAS GIVEN BY NIECE

Little Miss Eleanor B. Wilson Recited "Washington's Crossing" at School Exercises

Miss Eleanor B. Wilson, daughter of Mr. and Mrs. Walter P. Wilson of 476 West Hanover Street, who participated in the Washington's Birthday celebration held at the new Gregory School last week, pleased by reciting a Washington's Crossing poem, which was composed by her uncle, T. J. Walker, of Lambertville.

Little Miss Wilson rendered the poem without the slightest hesitation. She is only ten years old and is a promising pianist. The poem is as follows:

WASHINGTON'S CROSSING.

Why leave unmarked the famous place
 Where Washington once led
His little band of valiant men,
 Unclothed, unshod, unfed,
To brave the water's icy snares,
 That this great nation live,
And yet in memory of that deed
 No honor give.

Save for the name, a moss-clad stone,
 No shaft nor columns rise
And yet no spot in this fair land
 Is more immortalized.
Is not the greatness of the past
 The crossing's cherished fame,
Enough to build a monument
 All worthy of the name?

Our country's boundless wealth grows on,
 The millions mount apace,
Yet not a copper, not a flag,
 To designate the place.
Our countrymen! this long neglect
 Is dead, I hope, for aye.
Buy up the land, lay out the walks,
 Our country's own alway.
 —T. J. WALKER.

MISS ELEANOR B. WILSON.

(Little Miss Wilson's recitation of a patriotic poem pleased at Gregory School)

The poem "Washington's Crossing," by Thomas John "T.J." Walker, was published for the second time on February 28, 1912, when it was recited by his niece, Eleanor Wilson, at her school celebration of Washington's birthday. Walker came to the United States from England in the 1890s and established a grocery in Lambertville, New Jersey, in 1912. Throughout his life, he was active in several fraternities, the Rotary, and his church. When he died in 1943, his obituary listed family and business accomplishments, but there was no mention of his poetry. First published in the *Trenton Evening Times* on January 25, 1912, just a few days after legislation had been introduced to purchase lands for the creation of a park, the poem asked, "Why leave unmarked the famous place / Where Washington once led." The bill was advocated by the Patriotic Order Sons of America, who said the poem had come at a time of "divine guidance." Several thousand copies were printed and sent to New Jersey's senators and assemblymen. The act to establish the WCSP was approved on March 8, 1912, less than two months after it was introduced, thanks in part to the inspirational words of T.J. Walker. (WCPAA.)

"Washington Crossing the Delaware," published in 1847, was composed by Charles Zeuner with lyrics by poet Seba Smith. The song was composed to be sung by a men's a cappella chorus. The words to Smith's poem reflect the bravery and dedication of those patriots who crossed the Delaware that Christmas night: "How the strong oars dash the ice / Amid the tempest's roar, / And how the trumpet voice of Knox / Still cheers them to the shore! / Thus in the freezing midnight air / Those brave hearts crossed the Delaware." (AC.)

"My Dream of the USA" was published in 1908 with words and music by Leonard Chick, Charles Roth, and Ted Snyder. The composition was originally written as a solo and was later arranged by Alfred J. Boyle as a male quartet. The content is of a dream sequence of a young soldier that begins with Washington crossing the Delaware and continues to recount important events and military figures tracing the history of the country. (AC.)

"Dear Old Trenton" was composed in 1926 by Albert Watson and sung by William J. Fleming and James Newell to commemorate the sesquicentennial of the Battle of Trenton. Written in a march tempo, its words "When from old Delaware's ripping stream / Brave men had crossed and marched unseen / And won the fight that did redeem / Sweet hopes of Liberty" depict Washington's triumphant victory over the Hessian army, which occupied Trenton, on Christmas day 1776. (TFPL.)

This 1918 patriotic song composed by George W. Meyer, with lyrics by Howard Johnson and published by Leo Feist Inc., describes America's effort during World War I. It draws a direct parallel to the American Revolution in hope that Gen. John J. Pershing, whose image appears below a painting of George Washington crossing the Delaware River, will have the same success as Washington during the Battles of Trenton and Princeton. Pershing served as the commander of the American Expeditionary Forces on the Western Front in World War I. (LOC.)

During World War II, the US government issued war bonds and stamps to finance military operations. The government recruited famous artists to design posters and Hollywood celebrities to host support rallies. This one of Washington crossing the Delaware, created in 1942 by artist James Henry Daugherty, was one of four posters in a series he created depicting America's fight for independence. (University of North Texas Libraries Government Documents Department.)

The Lloyd J. Harriss Pie Company opened in the 1930s with operations in Chicago and Saugatuck, Michigan. The company produced frozen fruit along with various fresh and frozen fruit pies that were delivered to the Chicago market. This 1947 Lloyd J. Harriss Pie Company poster shows George Washington crossing a river of cherry pies. It is a spoof of Emanuel Leutze's painting of *Washington Crossing the Delaware*. (LOC.)

Discover Thousands of Local History Books
Featuring Millions of Vintage Images

Arcadia Publishing, the leading local history publisher in the United States, is committed to making history accessible and meaningful through publishing books that celebrate and preserve the heritage of America's people and places.

Find more books like this at
www.arcadiapublishing.com

Search for your hometown history, your old stomping grounds, and even your favorite sports team.

Consistent with our mission to preserve history on a local level, this book was printed in South Carolina on American-made paper and manufactured entirely in the United States. Products carrying the accredited Forest Stewardship Council (FSC) label are printed on 100 percent FSC-certified paper.